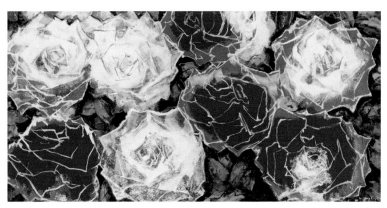

합창하는 장미들
2010, Acrylic on Canvas, 200.0×400.0cm

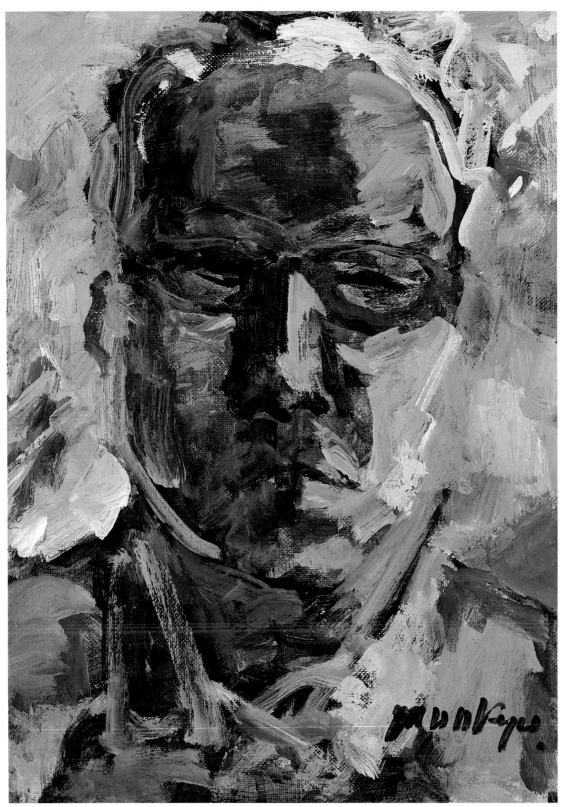

화가의 초상
Portrait of an artist, 2010, 53×45.5cm

Art Cosmos

정문규

Chung Mun Kyu

서문당

정문규
Chung Mun Kyu

초판 인쇄 / 2011년 4월 15일
초판 발행 / 2011년 4월 25일

지은이 / 정문규
펴낸이 / 최석로
펴낸곳 / 서문당
주소 / 경기도 파주시 교하읍 문발리 514-3 파주출판단지
전화 / (031)955-8255~6
팩스 / (031)955-8254
창업일자 / 1968. 12. 24
등록일지 / 2001. 1. 10
등록번호 / 제406-313-2001-000005호

ISBN 89-7243-644-5
잘못된 책은 바꾸어 드립니다.

차례
Contents

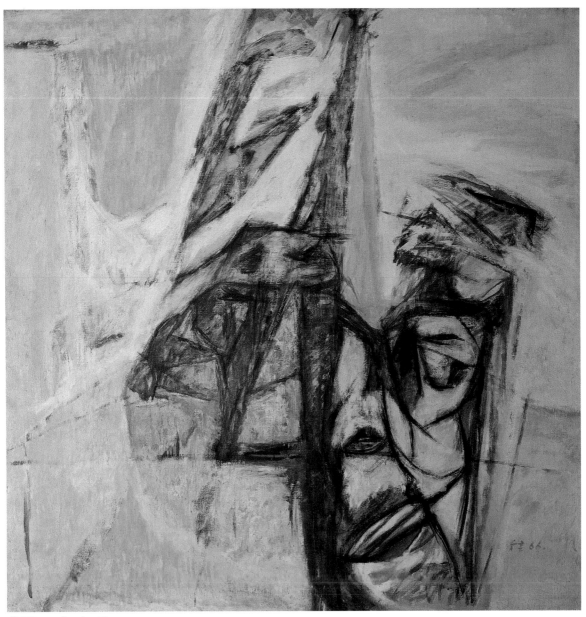

祭日 Ⅲ Sacrifice day Ⅲ
1966, Oil on Canvas, 112.0×112.0cm

樞軸 A Pivot
1966, Oil on Canvas,
162.2×112.2cm

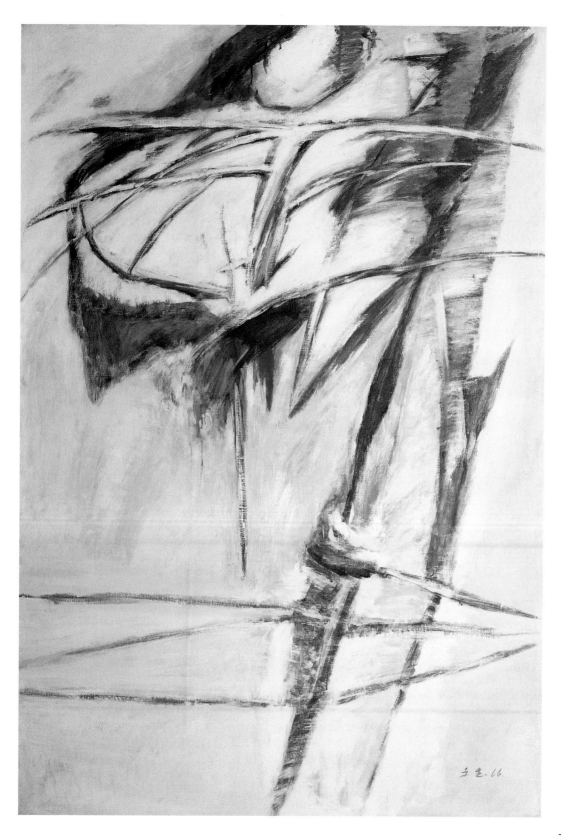

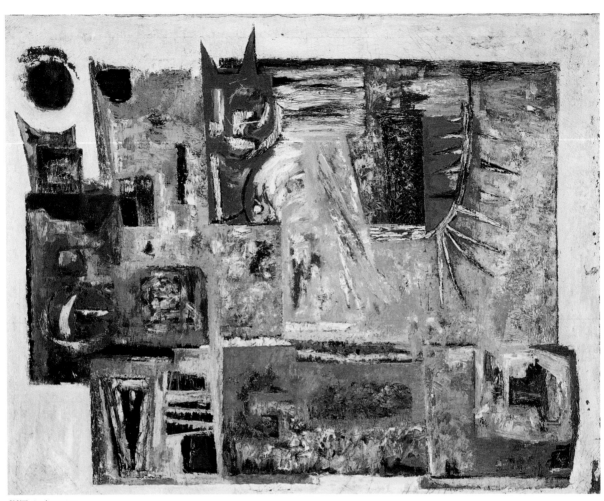

斷層 Oislocation
1958, Oil on Canvas, 130.3×162.2cm

"나의 가장 바람직한 목표는
완전한 자유를 가지고 그것을 향락할 수 있는
정신적 위치까지 나를 밀고 가는 일이다.
조금도 작위성이 없는
그리고 순수하게 응결된 내면을 가지고
그것을 설득력 있게 형상화하는 것이다."

정문규 자술 | 종합예술지 『공간』 1976년 11월 호

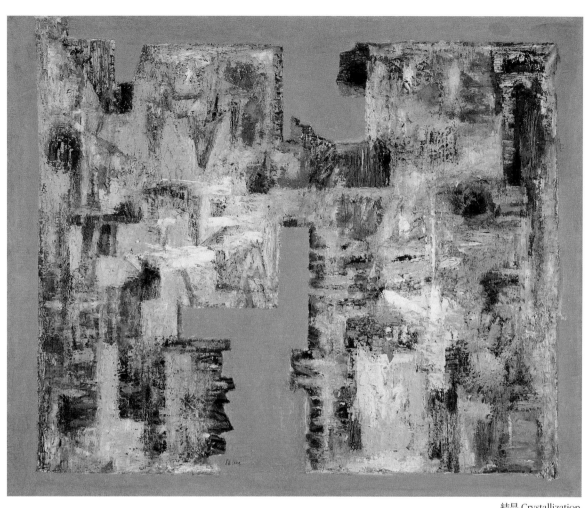

結晶 Crystallization
1959, Oil on Canvas, 80.0×100.0cm, 예술의전당 한가람미술관 소장

"My ideal goal is
to possess complete freedom and push myself
to reach the mental status to be able to enjoy it.
I want to create something that
has a point of persuasion, with innocent inner soul,
absolutely free of artificiality."

In the interview With Chung,Mun-kyu Art magazine 『Space』, November, 1976

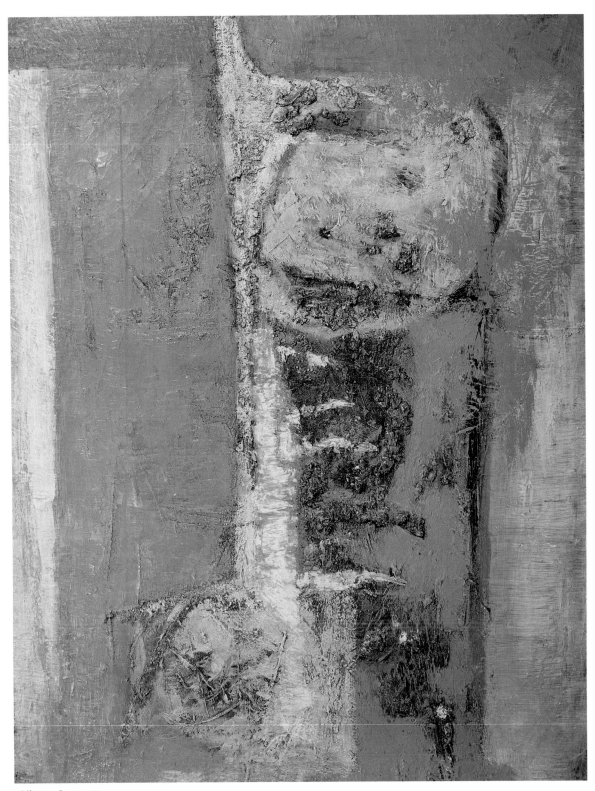

映像C Reflection C
1962, Oil on Canvas, 100.0×80.3cm

10

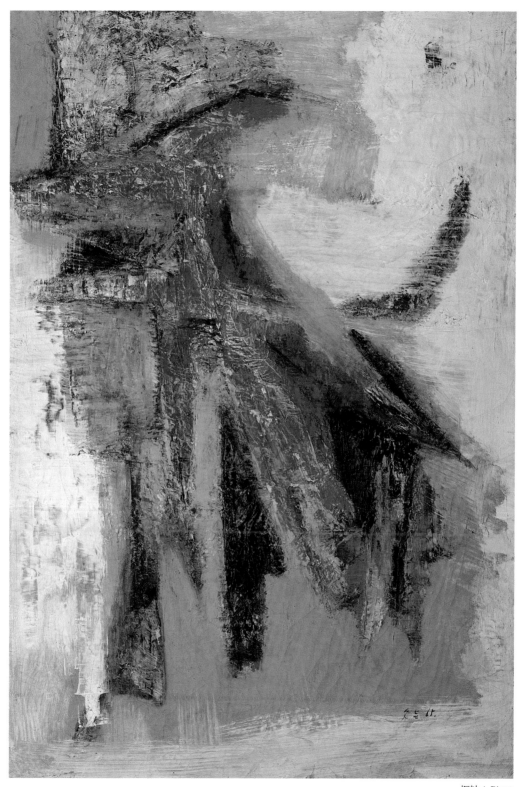

樞軸 A Pivot
1965, Oil on Canvas, 145.5×112.2cm

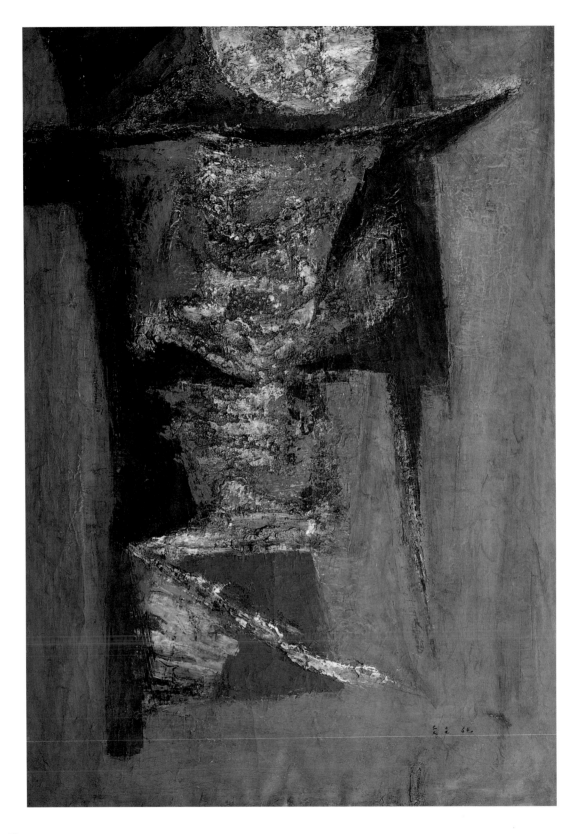

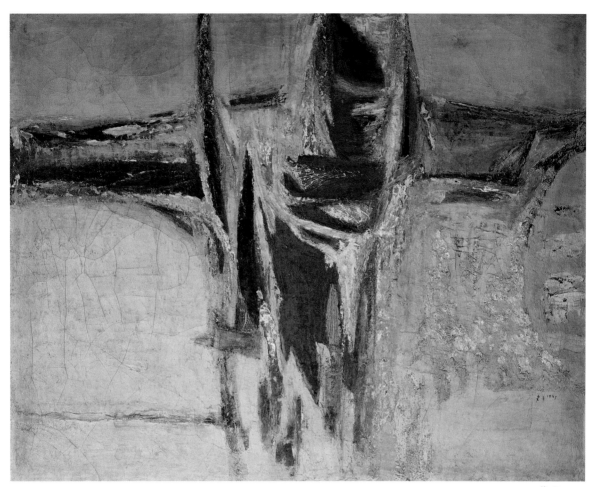

像 Image
1963, Oil on Canvas, 130.0×162.0cm, 부산시립미술관 소장

화면의 질(質)로서의 누드

오광수 / 미술평론가

人間 Human
1964, Oil on Canvas,
130.3×97.0cm

　　캔버스에다 일정의 물감을 칠하고, 그것이 마르기 전에 북북 나이프로 긁어내어 버리고는 다시 칠하고, 또 긁어내어버리는 작업을 거듭하는 이 작가의 일차적인 작업의 내용은 퍽이나 역설적이다. 캔버스에다 일정량의 물감을 발라 올리면서 그림이 완성되어 가는 것이 아니라, 발라 올라진 물감을 긁어냄으로써 그림을 완성시켜

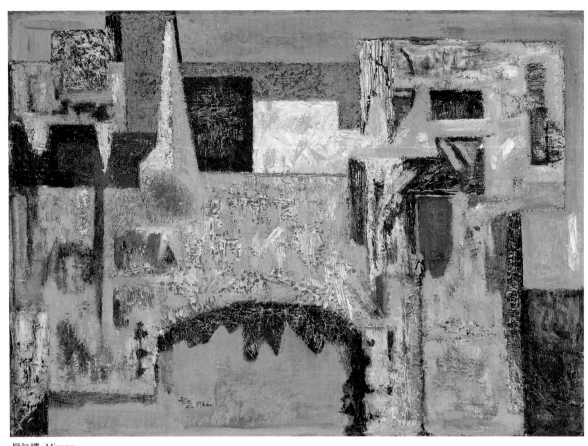

蜃氣樓 Mirage
1960, Oil on Canvas, 72.2×100.0cm, 부산시립미술관 소장

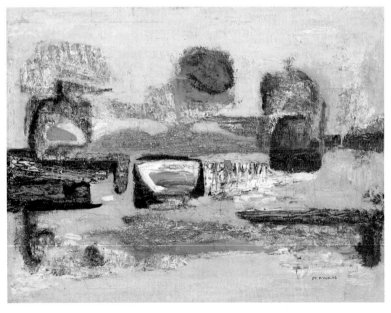

卓上 Table
1962, Oil on Canvas, 65.1×80.3cm

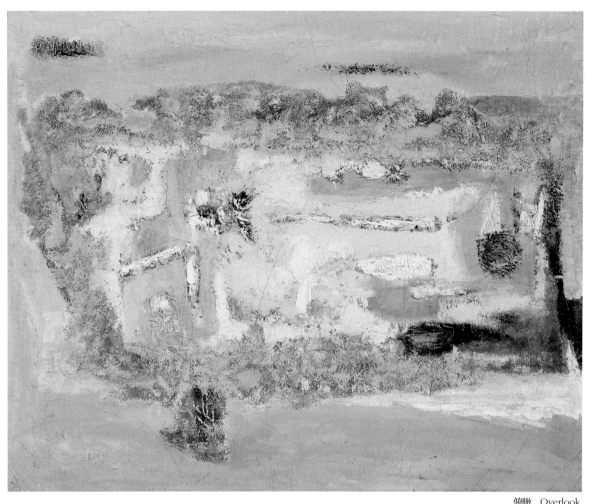

俯瞰　Overlook
1962, Oil on Canvas, 65.1×91.0cm

가고 있기 때문이다. 그것은 영락없이 그린다고 하는 행위가 곧 지운다는 행위와
일치함을 말해주는것이다.

　　대부분의 경우, 나이프로 긁어내다가 때로는 못으로 긁어내어 화면에 흠집을 만
들어 내기도 한다. 그러니까 실지로 화면에 칠해진 물감보다 긁어내어 버린 물감이
더 많음은 물론이다. 이런 부단한 과정을 통해서 화면상에 일어난 밀도와 뉘앙스를
포착하면서 화면자체가 그 어떤 표현성에로 나아가기를 지켜보는 것이다. 그러니
까 그가 지우고 있는것은 맹목적으로 지우는 것이 아니라. 그린다는 방식의 역(逆)
구조임이 분명하다. 여기에 지운다는 방식의 특별한 의미성이 포착된다. 그의 화면
엔 구체적으로 확인되는 시각적 대상을 갖고 있다. 누드이다. 때로는 하나로, 때로
는 군집(群集)으로 나타나는 누드이다. 그러나 그가 그리고 있는 누드는 누드라고

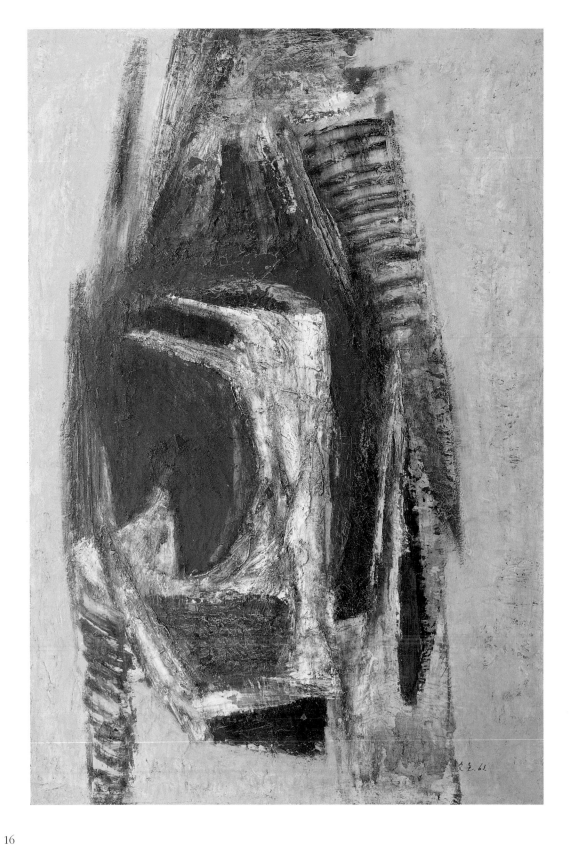

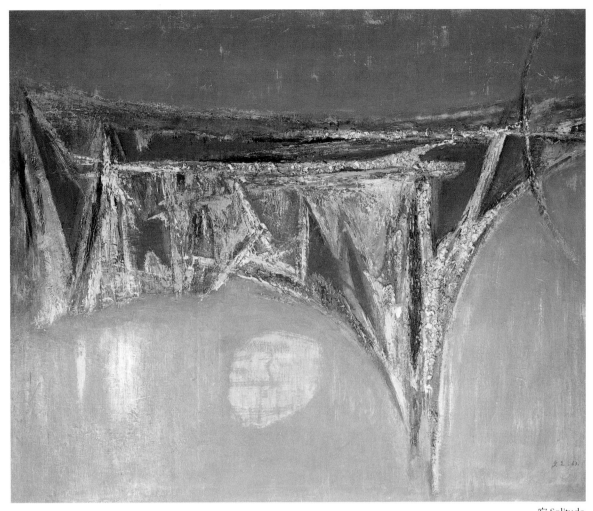

寂 Solitude
1963, Oil on Canvas, 130.3×162.2cm

映像 D Reflection D
1963, Oil on Canvas,
130.3×89.4cm

하는 일정의 대상을 옮겨 온 것은 물론 아니다. 왜냐하면 그의 일차적인 방법이 지운다고 하는 독특한 화면상의 관계에서 이루어지고 있는 것으로서, 대상성은 어디 까시나 이차적인것에지나지않기때문이다.

　다시 말하면 그가 누드에 어느 정도 관심을 갖고 있긴 하지만 누드가 실제로 존재하는 누드의 재현이 아니라, 화면 자체의 극히 자연 발생적인 방법을 통해서 생겨난 것에 지나지 않는다는 것이 이를 말해 주고 있다. 다시 말하면 어떤 구체적인 대상을 화면에다 그리는 것이 아니라, 화면 자체가 이떤 내상올 대신한 질(質)로서 모습을 나타낸다고 할까. 그의 부단한 긁어내기 작업은 대상성이라고 하는「일루전」을 지워가면서 그것이 화면의 구조화로 이르게 하는 미묘한 추이라고 할 것이다. 즉, 누드와 화면은 두 개의 상이한 질(質)로서 존재하지 않고, 일체화된다. 화면과 대상은 결코 분화(分化)되지 않는다. 화면 자체가 누드이고 누드 자체가 화면이다. 여기

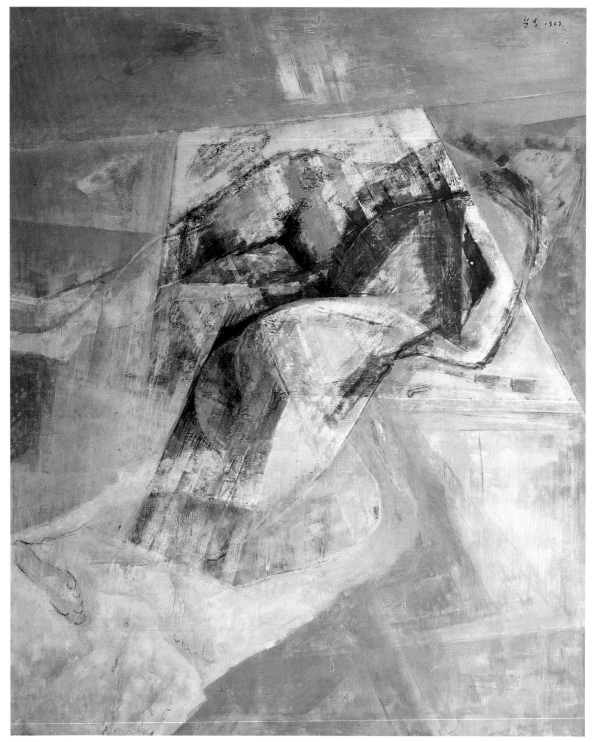

女3 Woman 3
1969, Oil on Canvas, 162.2×130.3cm

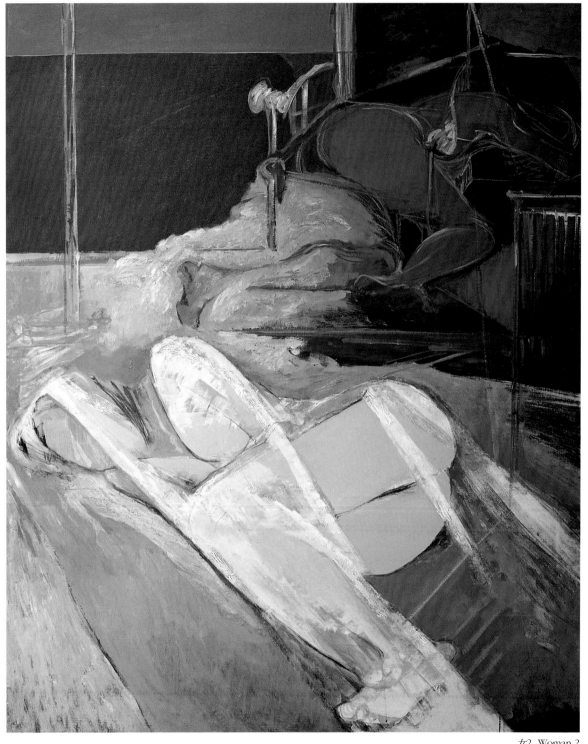

女2 Woman 2
1970, Oil on Canvas, 162.2×130.3cm

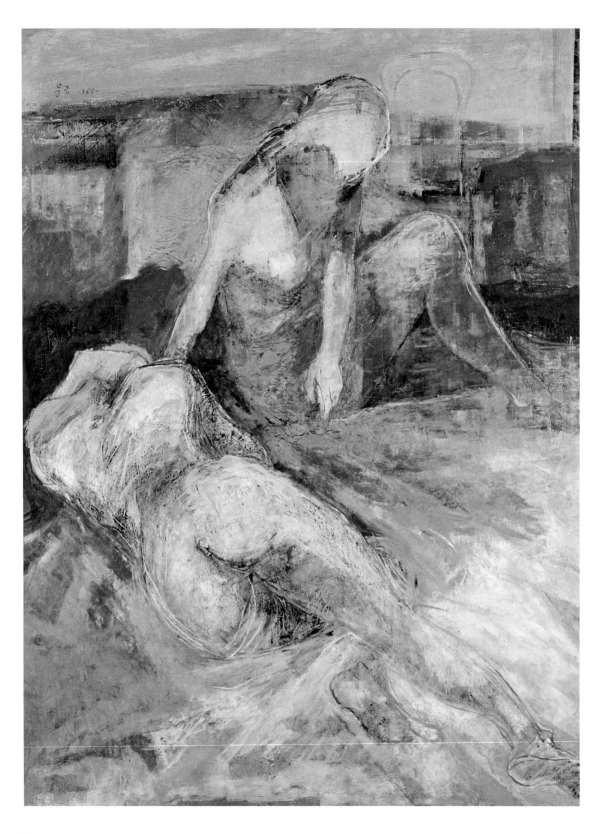

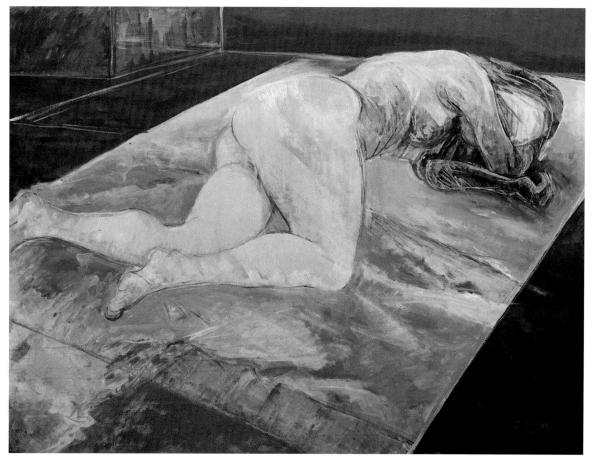

女7 Woman 7
1969, Oil on Canvas, 97.0×130.3cm

두女人 Two Women
1969, Oil on Canvas,
130.3×97.0cm

에 회화는 회회 이외의 아무 것도 아닌 다른 회화 자체의 독립성을 다시 읽게 된다.

　　정문규씨가 누드 시리즈를 발표하기 시작한 것은 대체로 70년대에 들어오면서
이다. 누드 시리즈를 발표하기 이전에는 구체적인 대상을 지니지 않는 추상작업을
지속해 왔다. 그의 작가적 편력을 보면, 50년대 후반에 등단하여 70년대에 이르기
까지 일관된 추상 작업을 지속해 온 것으로 나타나고 있다. 대체로 이 기간은 추상
표현주의(抽象表現主義)가 커다란 물결을 넘실하고 있을 때였다.

　　그의 작품 역시 한 시대적 추세 속에 묶을 수 있을 것이다. 그러나 그의 화면은
어딘가 모르게 고집스럽게 그러한 추세에 맹목적으로 휘말려들지 않는 강인한 방
법의 추이를 지속해 보였다. 한마디로 표현한다면 화면의 질(質)에 대한 방법적 추
고도 결코 새로운 것이 아니라, 초기의 방법적언속에지나지않는다고볼수있다.

　　물론 70년대에 들어오면서 구체적인 대상성을 끌어왔다는 점에서는 변모라고
할 수 있으나, 그의 지속적인 관심의 추이에서는 결코 어떤 변모도 아니다. 60년대
후반 경부터 추상 미술에 참여하였던 많은 작가들이 다시 구상적인 경향으로 변모
를 겪고 있는 경향을 볼 수 있지만, 그의 대상성의 등장을 이러한 일반적 경향 속에

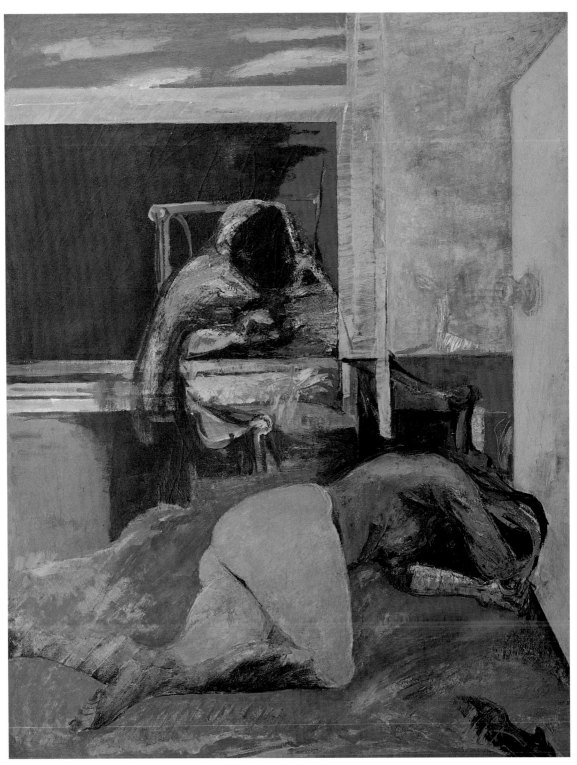

Composition女
1971, Oil on Canvas, 145.5×112.2cm

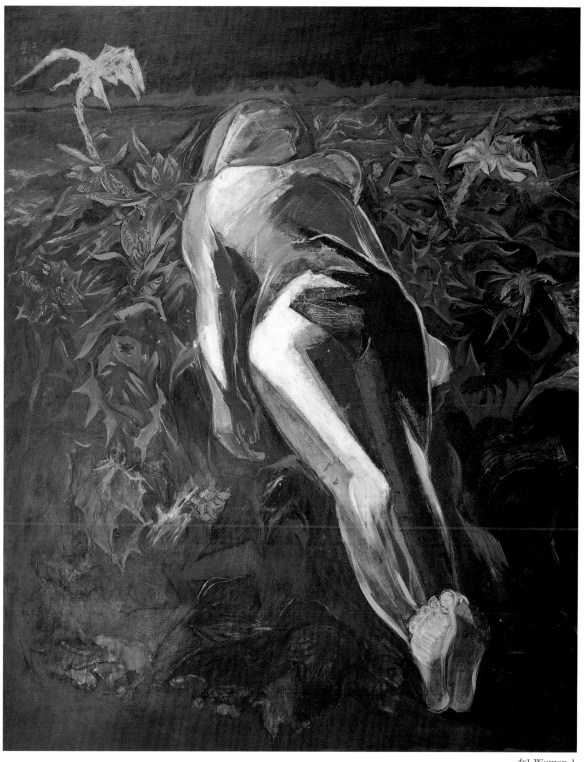

女1 Woman 1
1968, Oil on Canvas, 162.2×130.3cm

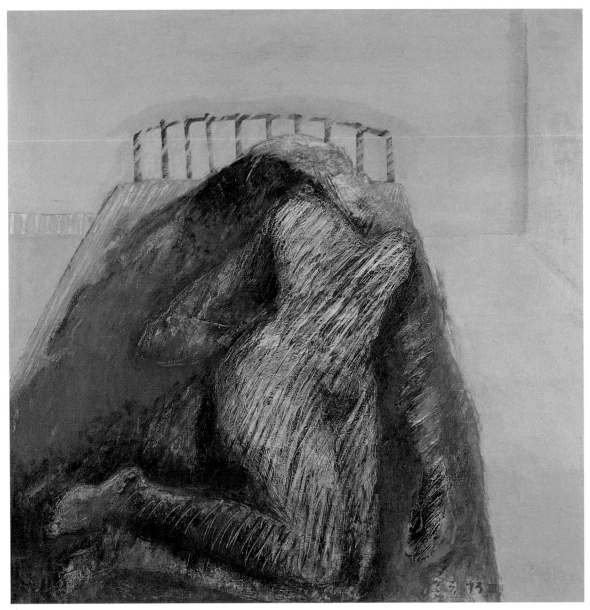

女11 Woman 11
1973, Oil on Canvas, 112.2×112.2cm

집어넣을 수 없는 요인도 이 점에 있다. 그의 70년대 초반의 누드에서는 다소 그러한 의심의 여지를 남기고 있지 않는 것도 아니다. 대체로 70년대 초반의 누드가 강렬한 대상성을 드러내놓고 있기 때문이다

　나 어느 사이에 이 같은 대상성은 화면의 질(質)로서 드러나기 시작하면서 그의 지속적인 화면상의 방법적 추고가 두드러지게 부상되기에 이르렀다. 다시 말하면, 그는 극히 한때의 추상 자체에 대한 관심을 겪고는 자신의 방법의 재확인에

女 Woman
1974, Oil on Canvas,
145.5×112.2cm

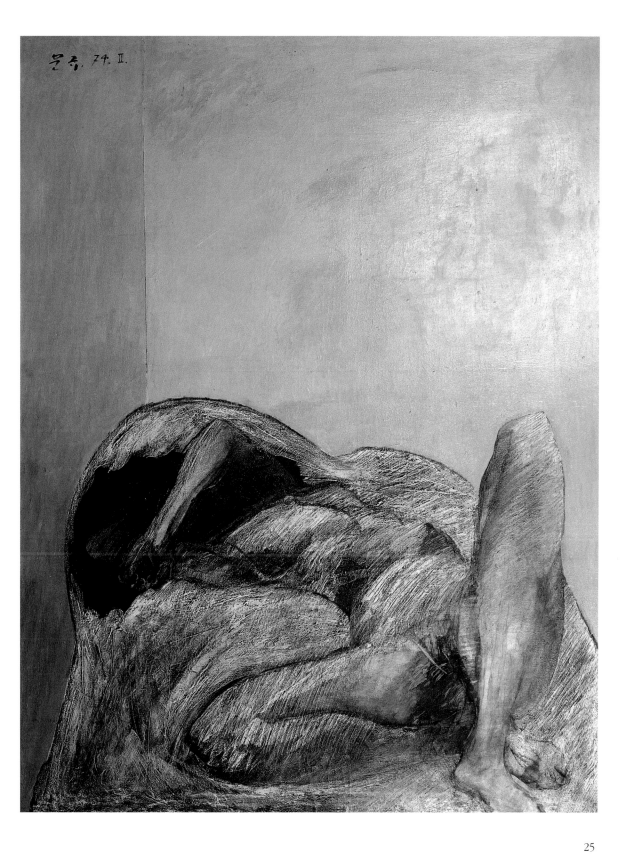

문숙. 74. Ⅱ.

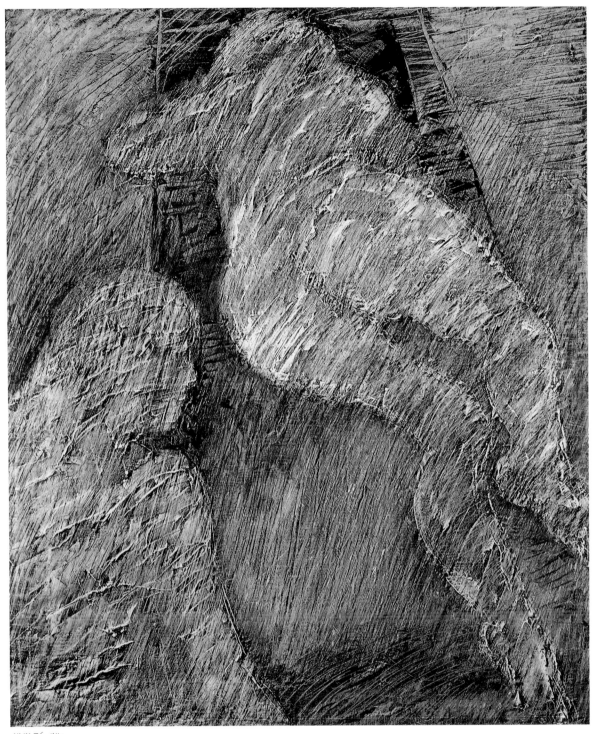

EVE 76-30a
1976, Oil on Canvas, 72.7×60.6cm

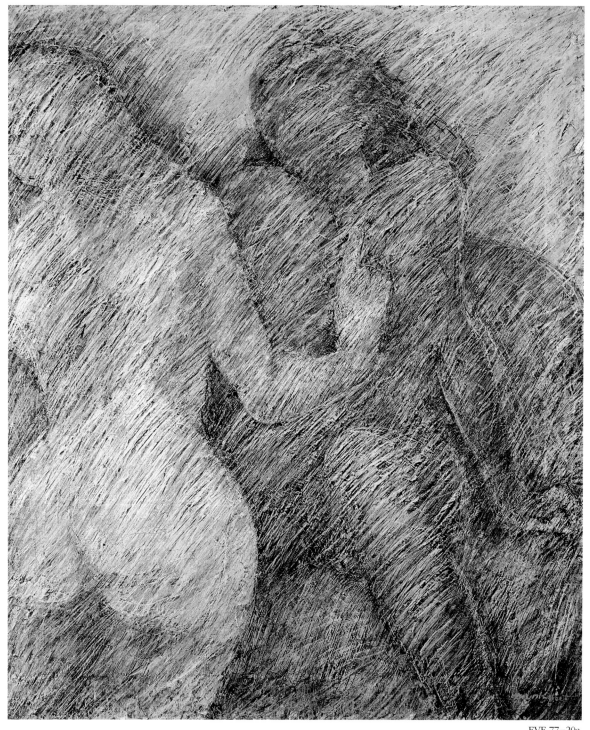

EVE 77-20a
1977, Oil on Canvas, 72.7×60.6cm

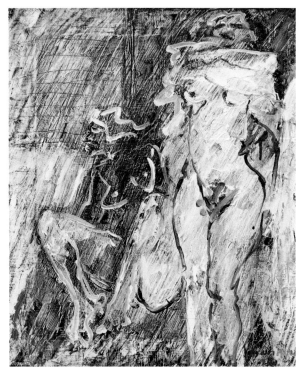

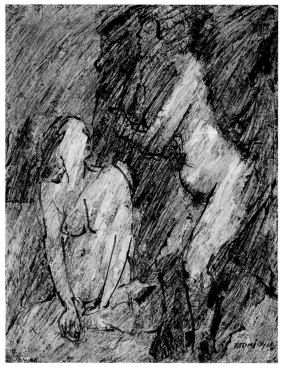

EVE 78-8c
1978, Oil on Canvas, 45.5×37.9cm

EVE 75-45_55
1979, Oil on Canvas, 40.6×32.0cm

이른 셈이다. 초기의 추상 경향이나, 누드 시리즈의 초기 작품에 비한다면, 최근 작품들에서 발견되는 특성은색채에 대한 대단히 금욕적인태도라 할 수 있겠다.

　다시 말하면 색채 자체가 극히 제한되면서, 화면에 명암이라고 하는 대비의 극적인 효과가 시도되어지고 있음이다. 이 같은 화면상의 특성은 그의 과거의 작품에 비한다면 확실히 두드러진 변화임이 분명하다. 그러나 그것은 어떤 단순한 표면상의 변화는 아니다. 색채를 통해 구체적으로 드러나는 대상성의 설명을 그만큼 지워 갈 수 있다는 것은 다름 아닌 대상 자체가 화면에로의 구조적인 심화 현상이기 때문이다. 누드 시리즈의 초기 작품들에서 강하게 떠오른 것이 에로티시즘이었음은 물론이다. 아직도 그의 작품을 관능적(官能的)인 단면(側面)에서만 보려는 이들이 적지 않을 것으로 본다. 적어도 누드가 관능(官能)의 일차적인 관심이란 점에서는 그렇게 생각할 수 있을 것이다. 그러나 그의 최근의 누드는 어떤 관능(官能)의 대상도 아니다. 그것이 굳이 관능(官能)을 들어낸다고 한다면 어디까지나 부수적인 것에 지나지 않을것이다. 왜냐하면 그는 결코 대상을 그리는 것이 아니라, 화면 자체의 구조성을 들어내는데 경주하고있기 때문에서이다.(1979년 개인전 카다로그)

EVE 77-30b
1977, Oil on Canvas,
91.0×72.7cm

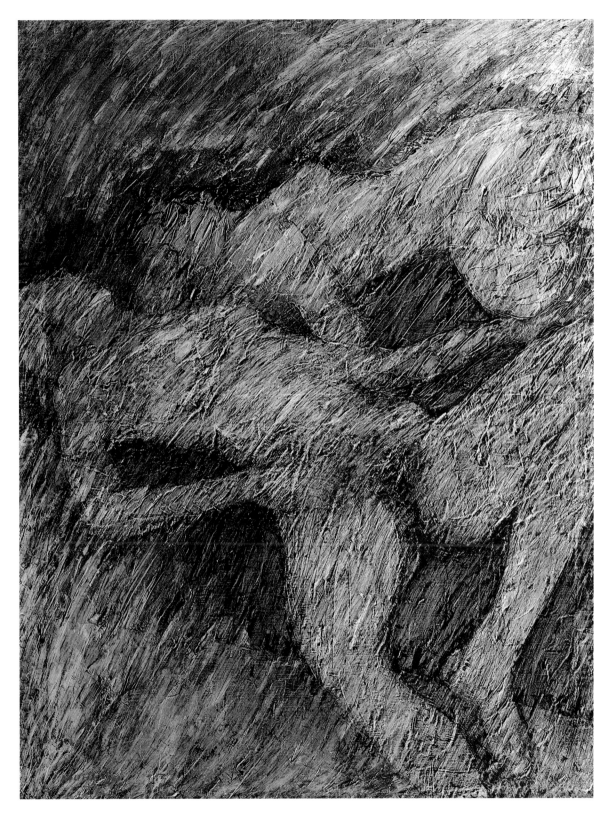

Nude as a character of canvas

Oh Gwangsoo / Art critic

The first stage of contents artworlds for this artist by applying an adequate amount of color on a canvas, scraping it off then painting it again after scraping it off with a knife it a very paradoxical method. Unlike finishing his work by painting an adequate amount of color, he finishes his piece by scraping it off. This shows an accord of action of painting with erasing. Most of the time, scar is made on the canvas due to more color wasted by scraping than color painting on the canvas.

His erasing is not just erasing, but a paradoxical action of painting. And there is a special meaning captured in this method of erasing.

There is a visual subject that can be identified specifically. Nude. It is sometimes shown as one, and sometime as a group. But, his nude painting is not just a nude subject on a canvas. The objectivity is only secondary because the primary method of erasing is achieved in unique relation with the canvas. Although he seems to have an interest in nude, it is not a reproduction of an exiting nude but a painting through a natural method on a canvas. Therefore it is not a painting of a specific subject on a canvas, but a character on a canvas that takes the place of the subject. His scraping work is a subtle transition to the canvas by erasing the 'illusion' of the objectivity. The nude and the canvas do not exist as a two separate charater, but diffrentiate.

The canvas and the subject do not canvas becomes the nude . Therefore the individuality of a painting of a painting being nithing else but a painting can be seen again.

It is relatively in the early1970's that Chung, Munkyu started to present hisd nude series. He continued on his abscact work without a specific subject before he released his nude series.

Looking at his history as an artist, he mounted the rostrum in 1950's and continued on his absract work until 1970's. This period was when abstact expressionism was in trend.

His works can be classified into a periodical trend. But there

EVE 79−101
1979, Oil on Canvas,
130.3×162.2cm

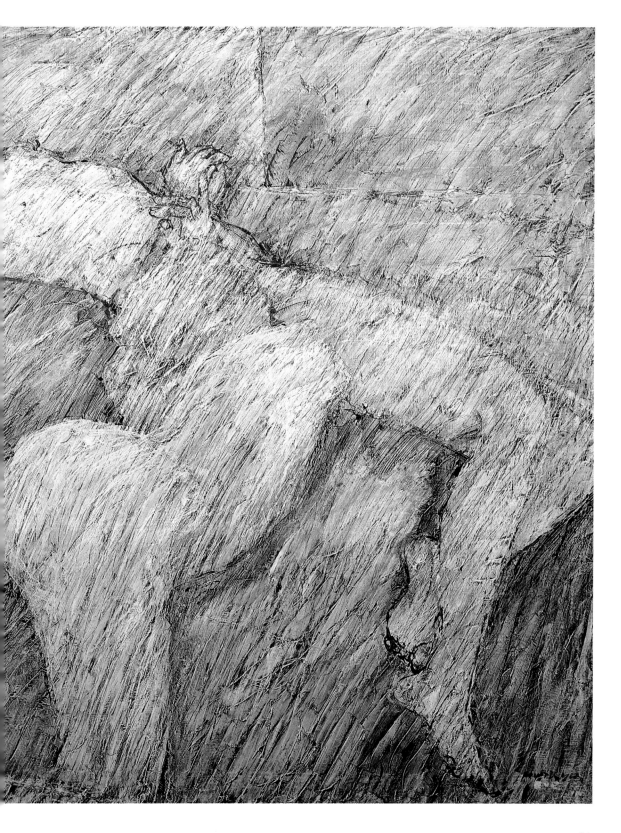

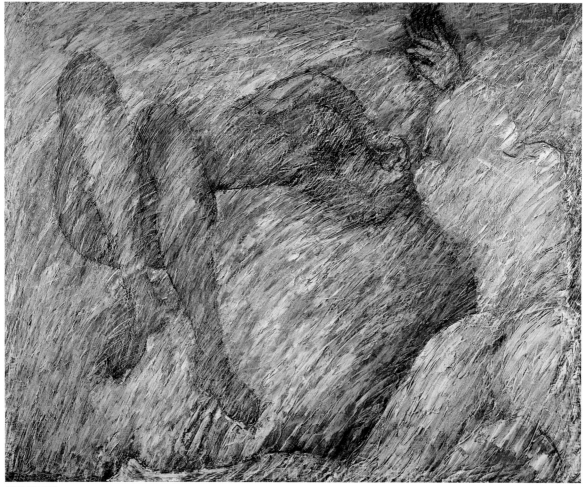

EVE 77-101
1977, Oil on Canvas, 130.3×162.2cm

is a coniuance of a strong method that did not get caught in those trends showing a stubbornness in his cancas. His methodical Improvement in relation to the character

Of canvas is not a new method, but difinitely not a change in his continuance of interest progression. A trend can be seen where artist, who were deeply involved in absract art, changed back again to the conception trend in the late 1960's, but a reason for his introduction of objectivity not being able to be classified in this general trend can also be found here. This does not mean that there is no doubt about this in his works in early 1970's.

Because relatively, there were strong objectivity shown in works fron early 1970's. But as his objectivity started to be dispalyed as a charater on a canvas, his coninuance of canvas method development became very prominent. Therefore, it seems he just showes a little interest in absracrt art

EVE 79-44_52
1979, Oil on Canvas,
52.5×45.3cm

EVE 79-40c
1979, Oil on Canvas, 80.3×100.0cm

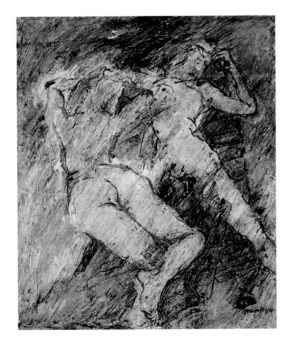

before he was able to reconfirm his style. There are abstinence of color in the characteristics of his recent works compared to his early absract trend or early nude series.

There seems to be a practice of using shading to give l a rge effects by limiting the color. This characeristical changes on canvas compared to his past works can be called a prominent change. But it is not just a simple change on the suface.

It is true that erotism can be largely seen in his early nude series. There art still many people looking at his works in the sensualistic piont of view. This might be because the primary interest in nude to be sensuality. But there is no subject of sensuality in his recent works. Of course if someone wants to find sensualiy, it can only be a secindary matter. This is because he is not drawing a subject, but concentrating on the structure of the canvas.(1979 In the catalog of solo Exhibition)

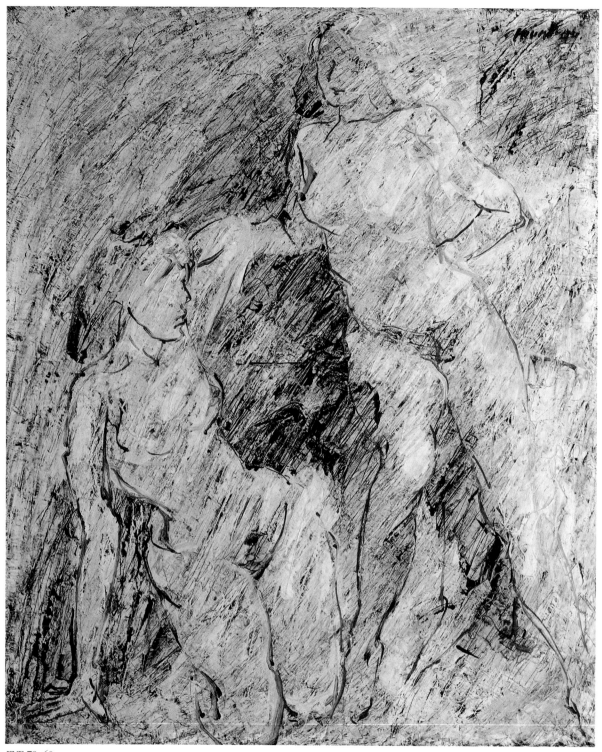

EVE 79-60a

1979, Oil on Canvas, 130.3×97.0cm

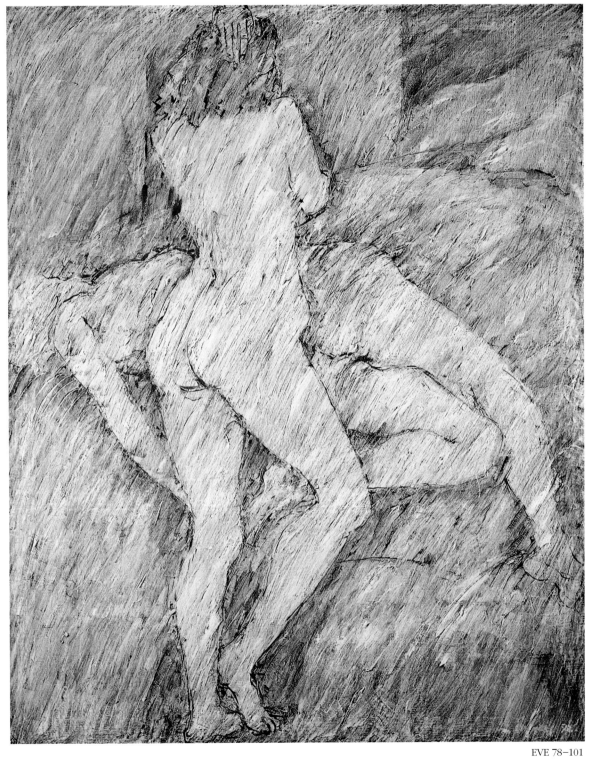

EVE 78-101
1978, Oil on Canvas, 162.2×130.3cm

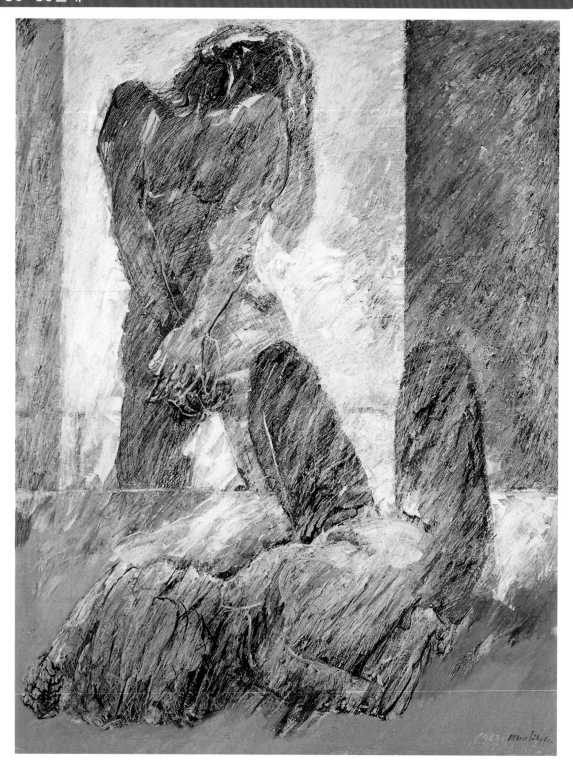

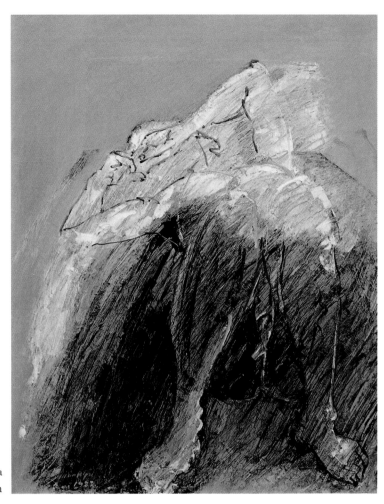

EVE 83–30a
1983, Oil on Canvas, 91.0×72.7cm

정문규(鄭文圭)의 세계(世界)

임영방 / 전 국립현대미술관 관장

　　지난날의 다양한 색채의 추상세계에서 흑백의 검소한 여체작품으로 전환하여 20년이 가까운 긴 세월동안 단일한 표현대상에 머무르고 있는 이유가 무엇일까? 그가 집요하게 고집하는「EVE·女」라는 세계에서 정문규는 작가로서 풀어야 할 어느 과제를 발견하였을 것이다. 과연 그 과제가 무엇인가를 엿보게 하여 주는 것이 여체소재의 기나긴 세월을 통하여 제작한 오늘날까지의 그의 수많은

EVE 82–80a
1982, Oil on Canvas,
145.5×112.2cm

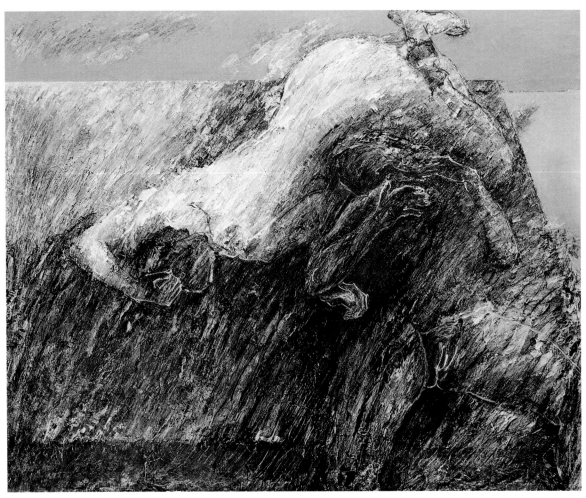

EVE 83-107
1983, Oil on Canvas, 130.3×162.2cm

작품이라 믿어진다. 한편, 오늘에 이르러 정문규는 작품에서 구상성의 흔적을
보이지 않도록 하는 것이 자신의 큰 문제로 되고 있다고 고민스럽게 실토한다.
58년 작「하천의 생태」라는 추상작품 등의 세계에서 여체세계로 전환하여 구상
성에서 멀어지고 싶다는 그의 오늘의 처지가 정문규의 예술을 엿보게 하도록 접
근시켜 준다. 일견, 그의 여체작품 세계는 단조롭고 변화성이 없는 좁은 시야의
세계로 보여진다. 그러나 이와 같은 그의 작품에 대한 시각은 크게 잘못 된 것이
다. 정확하게 말하자면 정문규는 여체를 작품으로 표현하기 위해서 여체를 구상
적으로 표현한 것이 아니다. 여체가 그에게 직접적인 표현의 대상이 되었다면,
이에 감각적인 색채를 동원하여 어느 면의 관능적인 여성의 특색을 고양(高揚)
했을 것이고 또는 모성적인 여체의 특성을 정상(淨上)시킬 수도 있을 것이다. 우
선 그의 작품이 어느 하나의 구체성을 보이는 점이 없다는데서 여체의 미적, 또

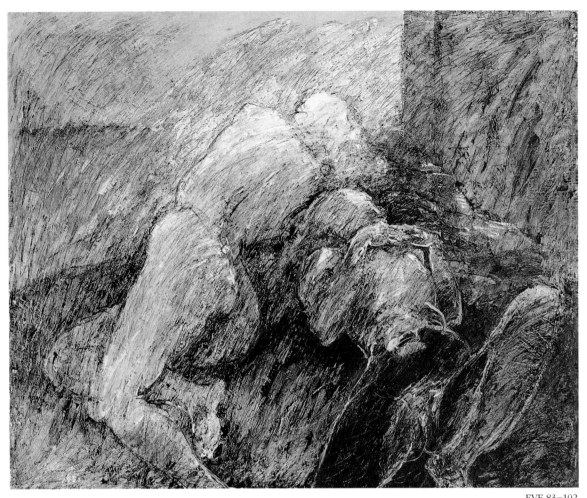

EVE 83-102

1983, Oil on Canvas, 130.3×162.2cm, 서울시립미술관 소장

는 관능적인 형태의 구현이 정문규가 갖고자하는 세계는 아닌 것이다. 그는 오히려 형상을 흑백의 색으로 소실케 하고, 거친 필적으로 분산시키고 있다. 그 세계는 어느 환상적인 영상, 또는 아득한 꿈의 흔적과 같다고 할 수 있다. 그렇다면 그의 작품세계는 어떠한 것인가. 희미한 흑백으로 엉킨 공간의 탄생과 그의 회화적인 우주의 표상을 정문규의 작품에서 감지할 수 있다. 작품에서 보이는 폐쇄된 실내 공간은 무한한 우주공간의 형식적인 표상에 불과하다.

　　어느 의미에서 생의 탄생 이전의 공간으로 보인다. 생의 태동(胎動)이 가능한 공간을 정문규가 이렇듯이 표상하고 있는 것이다. 이러한 공간 속의 여체의 여러 형상은 모든 생명체의 생성현상과 그 운명적인 시대성을 표상하고 있는 것이다. 그렇기에 거기에는 절망, 희망, 사색, 번뇌, 명상, 환희 등이 엇갈려 잠재되어 생의 문제를 암시하고 있음을 보여준다. 여체가 생명의 모체라는 생태적인 근원과 그것을 포

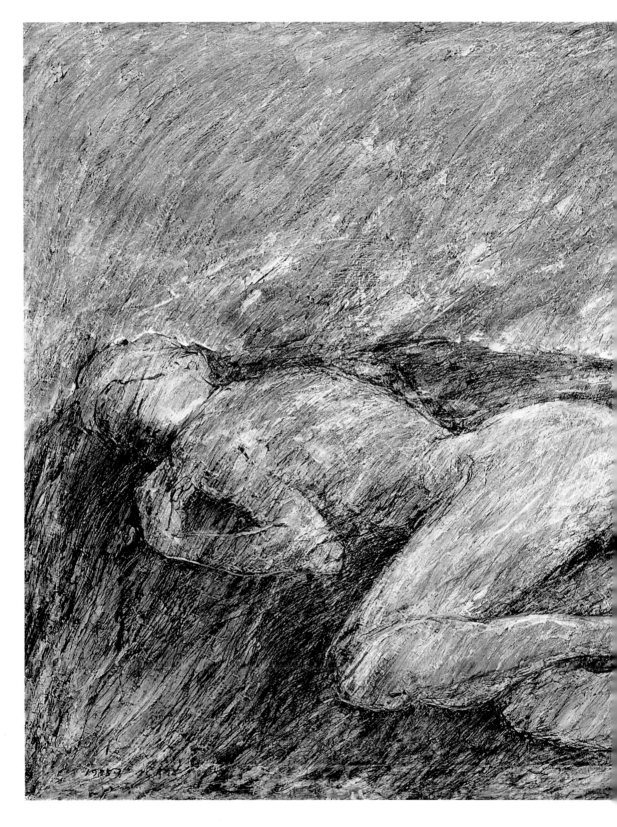

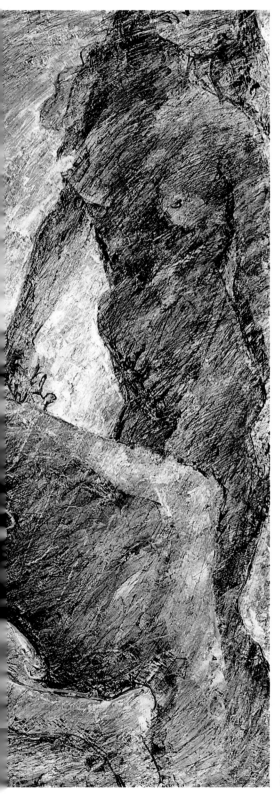

용하는 공간의 관계를 정문규의 작품에서 찾게 된다. 따라서 여체상은 가상적인 공간의 산물로 등장하고 있으며, 이에 공간은 거리나 깊이를 나타내는 주지적 공간이 아니고 창세기적인 공간으로 정문규는 표상하고 있는 것이다. 특히 주목할 점은 작품이 보여주는 두 형상의 정과 동차원 이라는 태극성(太極性)과 대립성(對立性)이다. 무에서 유, 탈에서 생, 이 상대적인 두 여인상으로 의인화되고 있는 것이다.

이것은 앞서 언급했듯이 창세기전의 혼돈 상태의 공간에서 생의 태동을 표상하는 것이다. 작품의 여인상이 관능적 자태와 욕구를 나타내 보인다거나, 에로틱하다거나, 신비스러운 분위기를 조성하고 있다거나하는 상태의 것은 결코 아닌 것이다. 작품에서 의인화된 여인상들은 항상 와상과 입상, 좌상과 입상 또는 수동적인 것에 대하여 능동적인 것 등으로 대조를 이루고 있다.

화려한 생의 탄생이 있기에는 오묘한 태동의 진통이 있음을 시사하는 것으로 되어 있다. 복합적이고 심오한 생의 탄생의 철학적인 작가의 사색과 뜻이 작품을 통하여 제시되고 있는 것이다. 그렇기에 작가는 작품의 명제를「EVE」「女」로 하고 있고, 결코「女人」이라는 인격화된 명제를 쓰지 않고 있는 것이다. 그러나 오늘날, 의인화된 상들이 혼돈상태의 공간이 아닌 물리적 공간에 등장될 때에 촉감적이고 감각적인 상으로 둔갑할 수도 있을 것이다. 이 점은 물론 작가의 창조적인 구상여하에 따른 가상적인 다음 단계의 작품이라고 말할 수도 있다. 이 시점에서 정문규의 작가로서의 고민을 이해할 수 있는 것 같다. 구상적인 흔적을 어떻게 없앨 것인가 하는 그의 심정과 부면한 과제를 이에 다소나마 이해할 수 있는 것 같다.

여상으로 의인화된 그의 생에 관한 문제는 어디까지나 작가의 우주관과 철학적인 영역의 것이며, 공간과 시간차원에 관련되는 것이다. 이에 형상은 그 과제를 잘못 유도할 수 있고 또한 사색적 추구에 지장을 주는 요소로 될 수 있다는데서 정문규는 형상표출에 거리를 두고자 하는 것이다. 20년 가까운 세월 동안 여상이라는 단일상에 머물고 있는 연유는 정문규가 품고 있던 과제가 해소될 수 없는 심오한 생과 생 이전에 관한 철학적인 문제였던 까닭이다. 색채가 등장할 수 없는 이유도 감가적인 세계와 무관한 그의 과제이기 때문이다. 이와 같은 정문규의 사색적인 작품의 배경이 그의 예술에서 일의적인 것으로 지적되어야 할 것 같다.

한편, 그의 회화적인 면에 대한 감상은 우선 공간성에 관한 지적으로 시작할 수 있다. 화면상에 폐쇄된 실내공간은 어느 일정한 고

EVE 85-103
1985, Oil on Canvas, 130.3×162.2cm, 국립현대미술관 소장

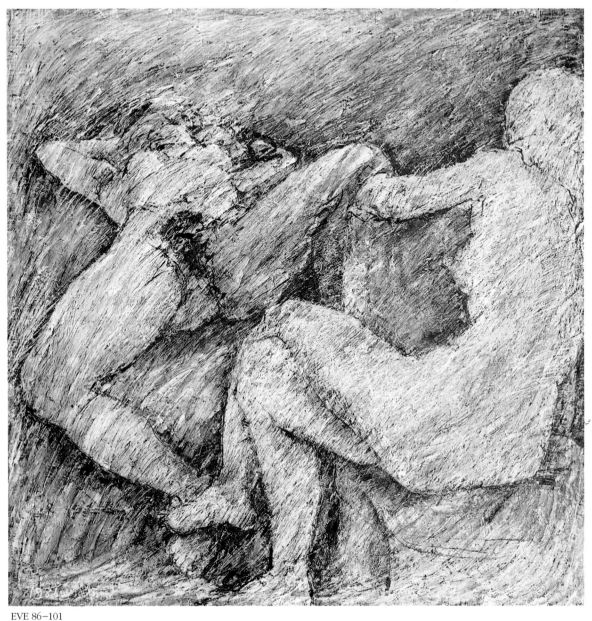

EVE 86-101
1986, Oil on Canvas, 130.0×130.0cm

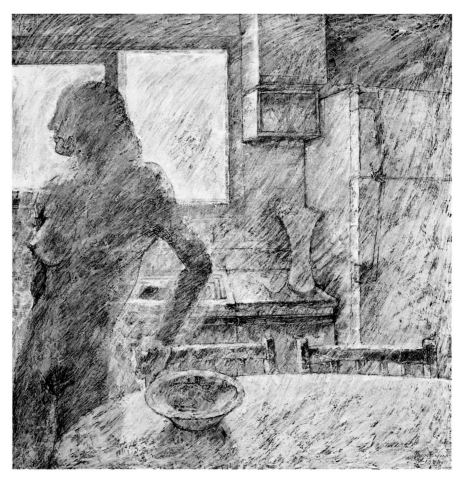

EVE 86-101
1986, Oil on Canvas,
130.0×130.0cm

정된 공간이 아니고 창세기적인 무한의 추상 공간이다. 그것은 화면의 배경요소가 가공적이고 어느 실내공간의 구성적 연관이 없는 상태의 것이라는 점에서 지적된다. 또한 화면의 형상은 항상 독자적인 공간적 위치를 차지하고 나타나 있는 점이다. 이러한 표출은 공간의 종속성을 시사하는 것이며, 조형에서 발생하는 공간성을 나타내는 것이 아니다. 따라서 형상의 공간적인 시각적 관계를 무시한 표현이라 할 수 있다.

근작에서, 정물이 온연하게 여상과 함께 제시되고 있으나, 그 물체가 놓여져야 할 회화적인 구성조건이 없는 상태를 볼 수 있다. 다시 말하자면, 공간적 구성관계가 없는 상태에서의 정물들인 것이다. 배경, 정물 등의 이러한 등장은 무와 유, 탈과 생의 대조성을 시사하는 표현형식이고 가공적인 것이라 할 수 있다. 따라서 표현할 수 없는 공간성을 거리 없는 무한한 상태로 화면에서 전개시키고 있으며, 공기와 빛이 거기에서 생의 태동을 가능케 한다.(1987 개인전 카다로그 中)

The World Of Chung, Mun-kyu

Lim, Young-bahng / Pre-director of National
Museum of Modern Art

What is the reason for remaining in subject expressionism of made women in black and white for a long 20 years after changing from various colors of abstract world of the past? Chung, Mun-kyu has found his theme as an artist in the world of 'Women', 'Eve'.

His many works of art arriving to this day shows the theme that he has found through these long years. Chung, Mun-kyu has said that his greatest problems was not showing any form of abstract art in his works.

Chung, Mun-kyu's desire to move far away from abstract art by changing from the world of his abstract work such as 'Ecology in the afternoon' to the world of naked women brings us closer to him in understanding his current works of art. At one sight, his world of naked women seems to be a world with a simple and a narrow vision. But, these views are critically wrong in admiring his works.

Actually, Chung, Mun-kyu does not use naked women so that they can be visualized and expression, he would have used more sensational coloring and expressed the characteristics of women in many ways or maybe express motherly characteristics of women. There being no concreteness in any one of these in his works, shows that the beauty of sensuality of naked women is not what Chung, Mun-kyu desires in his artistic world.

He rather destroys the subject by using colors black and white, and disperses through rough strokes. his world is like a fantastical vision, or traces of forgotten dreams. Then how is his world of art? The birth of vague black and white mixed together and the symbol of his painting world can be seen in Chung, Mun-kyu's works. Closed spaces seen in his works are just formal symbols in his unlimited world.

In some ways, it seems like a space before birth was ever born. Chung, Mun-kyu expresses fetus movements of birth. Many forms of women in these spaces express the formation

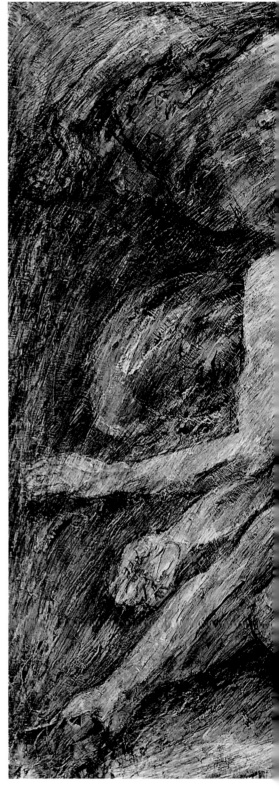

EVE 86-101
1986, Oil on Canvas, 130.3×162.2cm, 서울시립미술관 소장

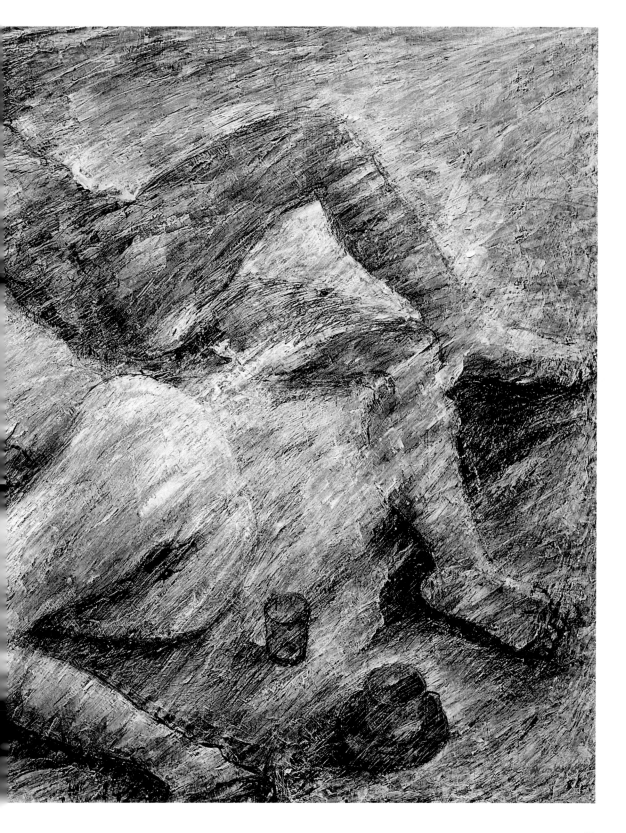

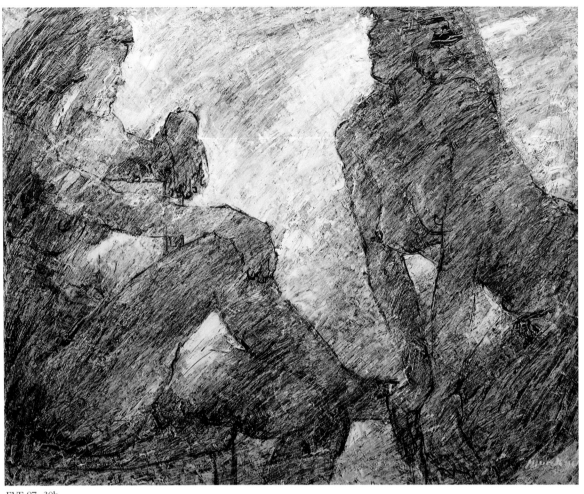

EVE 87−30b
1987, Oil on Canvas, 72.7×91.0cm

of life and the fatalistic time. Therefore there is despair, hope, contemplation, anguish, meditation and joy, all mixed with one another foretelling the question of latent life. The relationship of the basis of ecology, which is the mother of life shown as a naked women, and the space surrounding it can be found in the works of Chung, Munkyu. Therefore, Chung, Mun-kyu expresses the women's body to appear in a virtual space a s an object, and the space is not just an intellectual space showing the depth and the distance, but a space expressed as genesis. Especially notable point is the two figures in his work showing peace with contraposition and Yinyang. It is personified through these relatively different two women from nonexistence to existence and death to life.

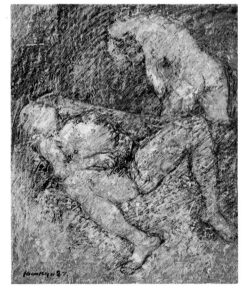

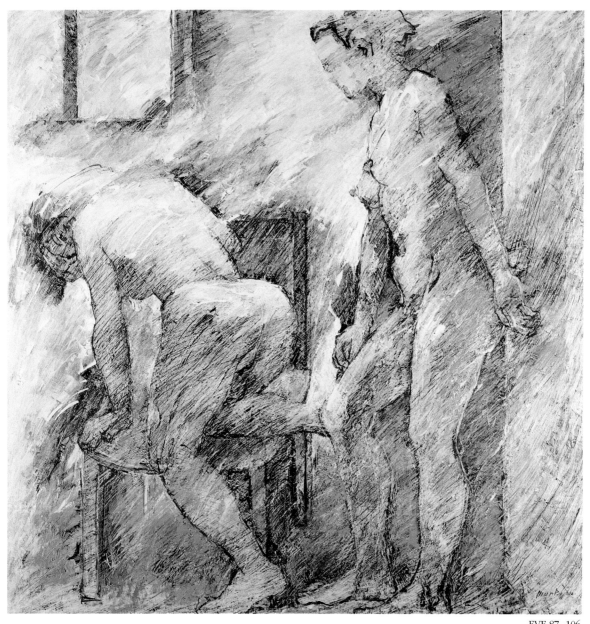

EVE 87−106
1987, Oil on Canvas, 130.0×130.0cm

EVE 87−10a
1987, Oil on Canvas,
53.0×45.5cm

This is a chaotic state of space before genesis expressing the fetus movement of life a mentioned above. Women are not expressed in a sensual pose showing desire, erotic or even miraculous. personified women figures in this work are always in contrast such as lying and standing, sitting and standing or passive and active.

It seems that there is a little pain in the movement of the fetus before the magnificent life is born. Complex and profound philosophical birth of

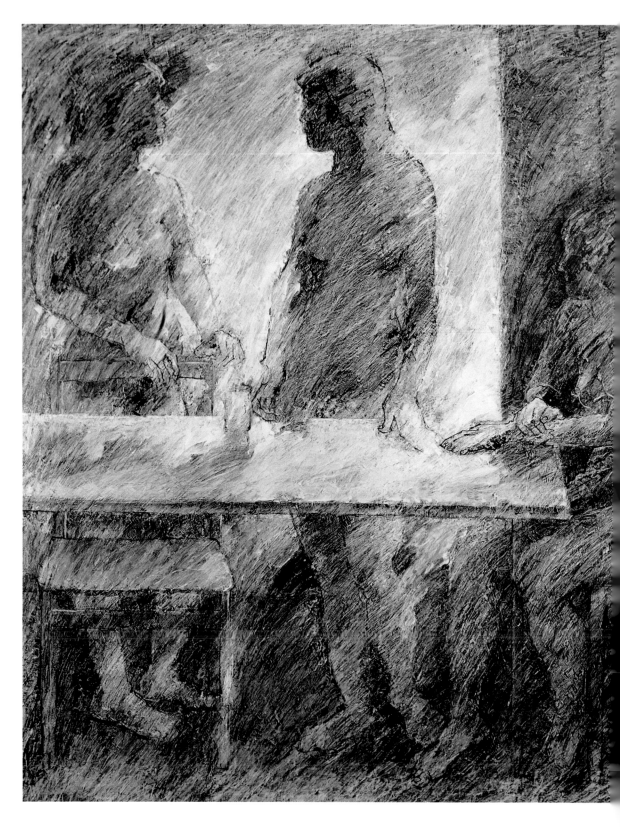

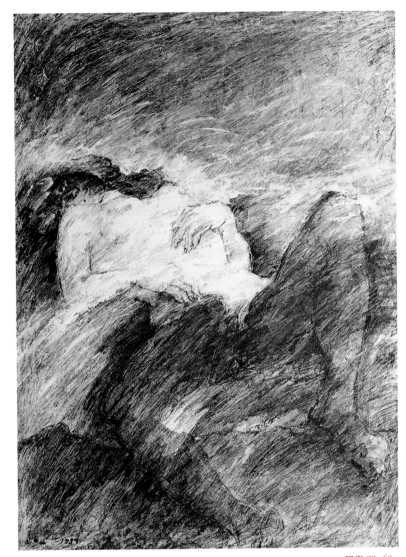

EVE 89-60a
1989, Oil on Canvas, 130.3×97.0cm

EVE 87-202
1987, Oil on Canvas,
200.0×200.0cm

life, which is the contemplation and the meaning of the artist can be seen through this piece. Therefore the artist named this piece 'Eve', 'Women' and not just 'Women' which is more personalized.

But in these days, figures that are personified can be transformed into figures with sensual and sensational characteristics in physical space and not in the chaotic state of space. This point of course is the creative ability of the artist which can be used in the next virtual stage of his creations. In this stage, the agony of Chung, Mun-kyu as a artist could be understood. A little of his feelings and inner question of getting rid of the concreteness could be understood.

The question of his life that have been personified through naked women

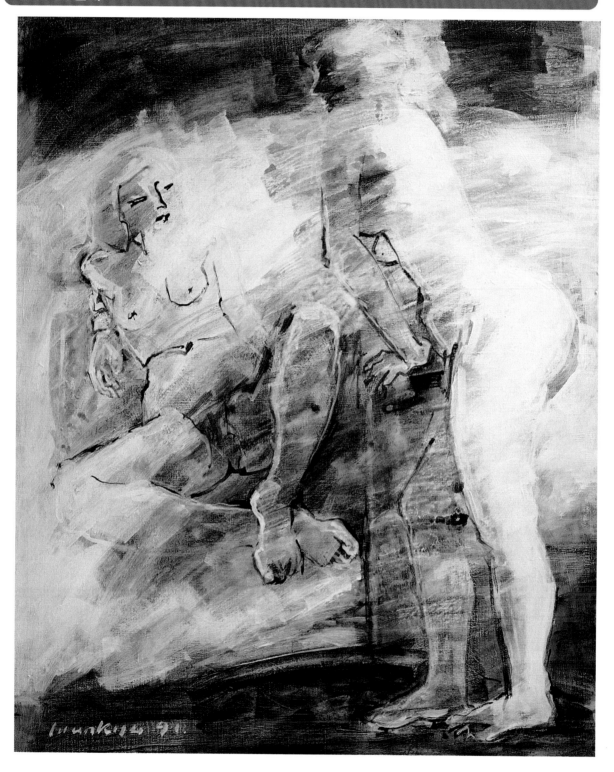

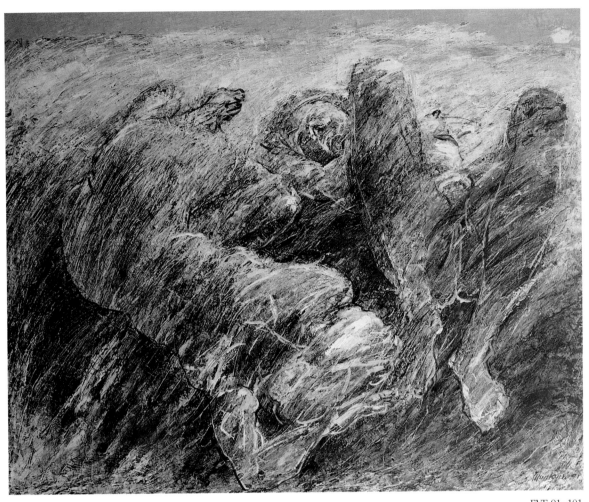

EVE 91−101
1991, Acrylic on Canvas, 130.3×162.2cm

EVE 91−20a
1991, Acrylic on Canvas,
72.7×60.6cm

is the boundaries of artist's outlook of universe and philosophy in relation to space and time.

Chung, Mun-kyu leaves distance to figure expressionism for this can be a factor in disturbing the pursuit of figures and also figures might mislead the theme.

The reason for Chung, Mun-kyu to remain in the subject of naked women is because of the philosophical question about life before genesis that could not be solved. The reason for not using any colors is also in relation to life before genesis. these contemplation of Chung, Mun-kyu in the background of his works is his singlemindedness which would be indicated.

On the other hand, we can start by indication his style of painting in relation to space. Closed inner space shown on the canvas is not a physical space, but an abstract space. Background factors on the canvas are empty and in a state without any relation to concreteness. And also the figures in

51

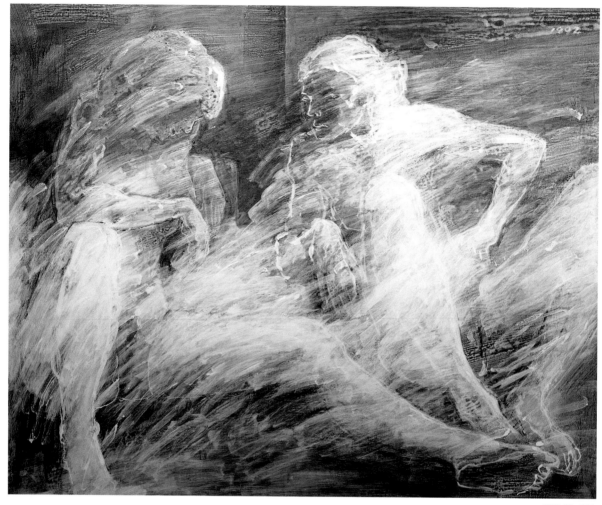

EVE 92−101
1992, Acrylic on Canvas, 130.3×162.2cm

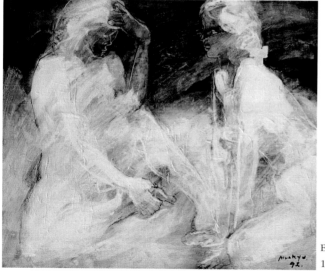

EVE 94−101
1994, Oil on Canvas,
162.2×130.3cm

EVE 92−15a
1992, Acrylic on Canvas, 53.0×65.1cm

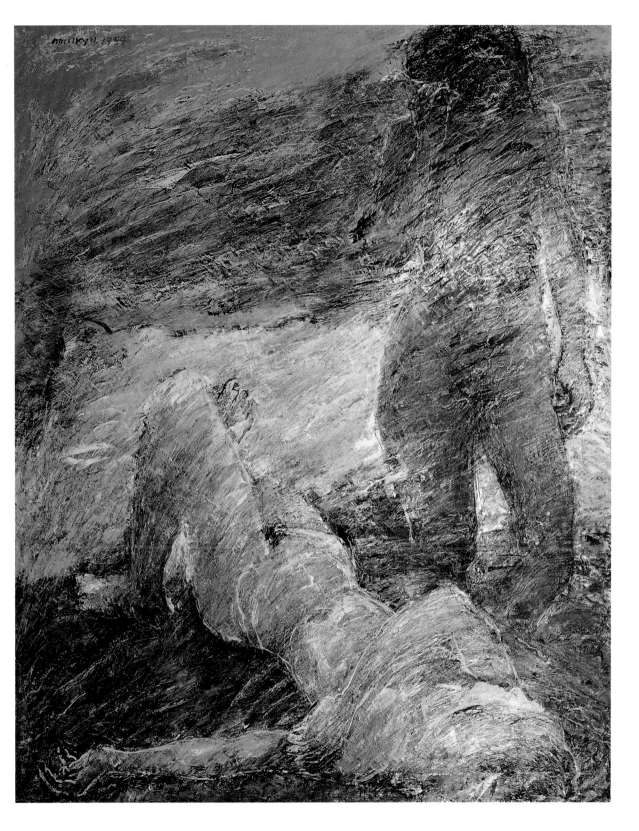

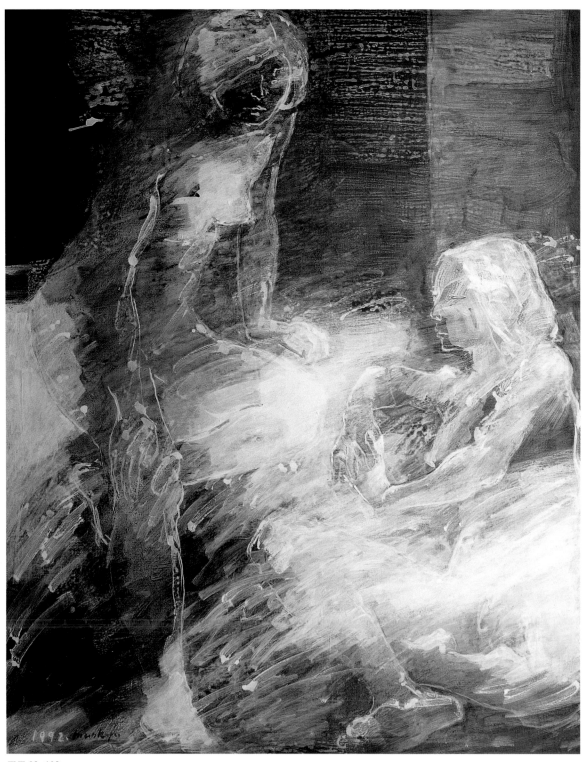

EVE 92-102
1992, Acrylic on Canvas, 162.2×130.3cm

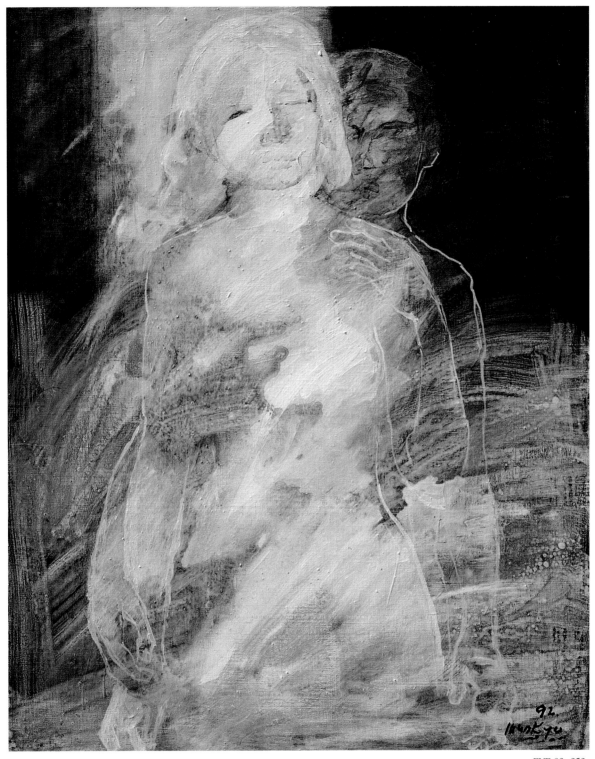

EVE 92-252
1992, Acrylic on Canvas, 80.3×65.0cm

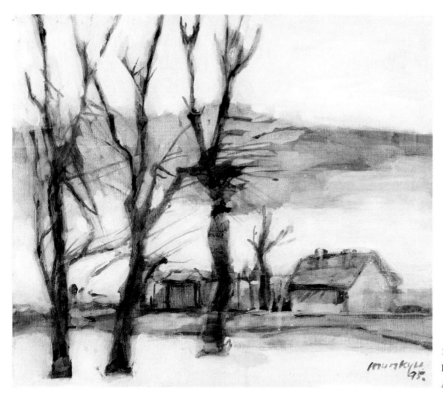

겨울풍경 I
Landscape of Winter I, 1995,
Acrylic on Canvas, 45.5×53.0cm 1995

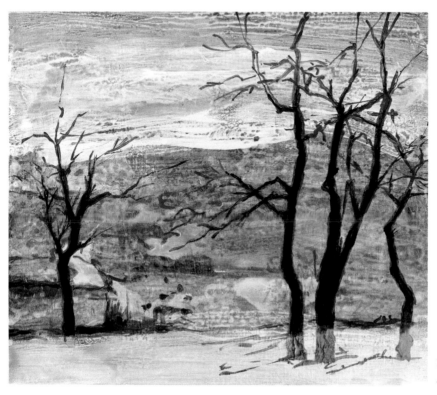

겨울풍경 II
Landscape of Winter II, 1997,
Acrylic on Canvas, 45.5×53.0cm

56

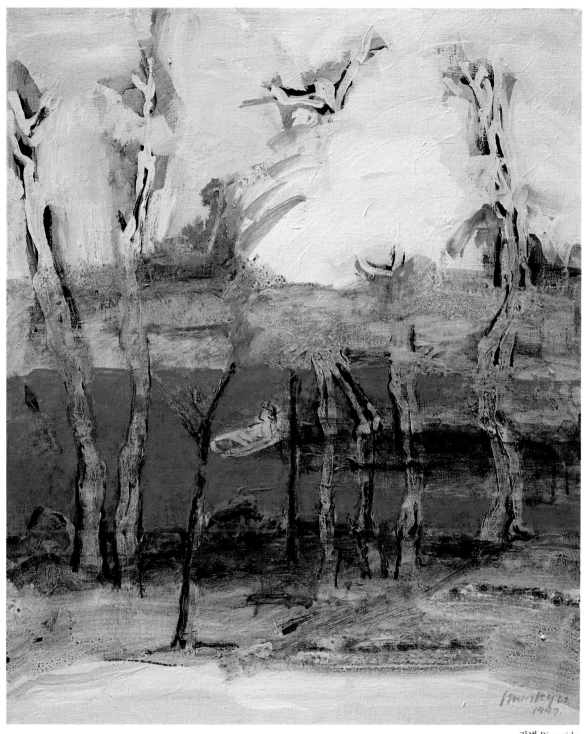

강변 Riverside
Riverside, 1997, Acrylic on Canvas, 72.7×60.6cm 1997

EVE 97−15c
1997, Acrylic on Canvas, 65.1×53cm

EVE 97−25a
1997, Acrylic on Canvas, 65.1×80.3cm

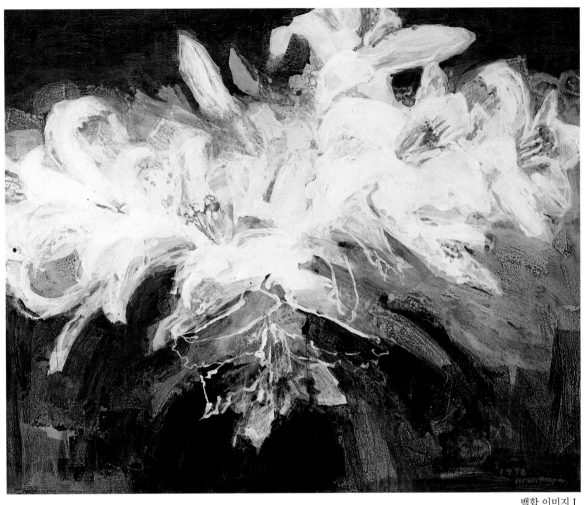

백합 이미지 I
Image of Lilies I, 1998, Acrylic on Canvas, 130.3×162.2cm

the canvas always have their own spacial location. These expression shows subordination of space, and does not show space developed from modeling. Therefore this can be called an expression ignoring the visual relationship of figures in space.

In his recent works, inanimate objects are presented with the figure if the women, but it is in a state where objects cannot be placed. In other words, they are inanimate objects in conditions without any relationship to space. The introduction of backgrounds and inanimate objects are expressing method showing contrast between nonexistence and existence, or life and death, and also very imaginative.

Therefore unexpressable space can be shown on canvas in the condition of unlimited space, and air and light makes it possible for the birth of life.(1987 In the catalog of solo Exhibition)

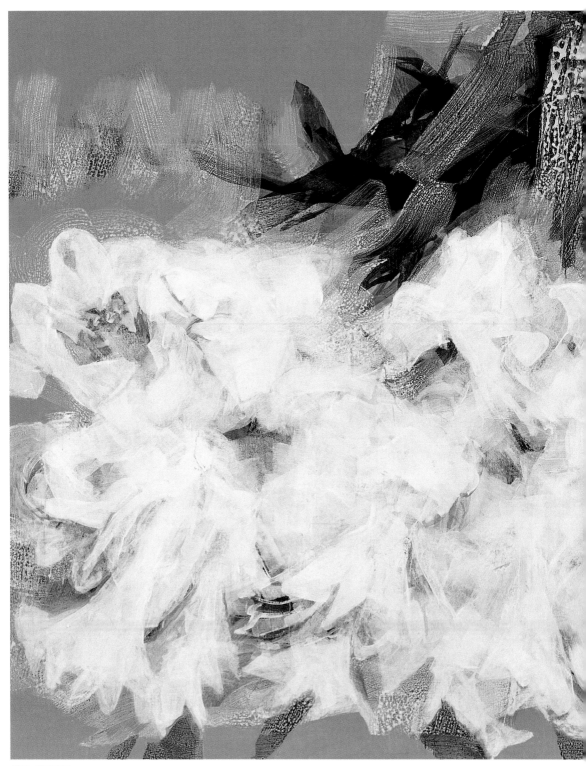

백합 이미지 IV
Image of Lilies IV, 1998, Acrylic on Canvas, 197.0×333.3cm

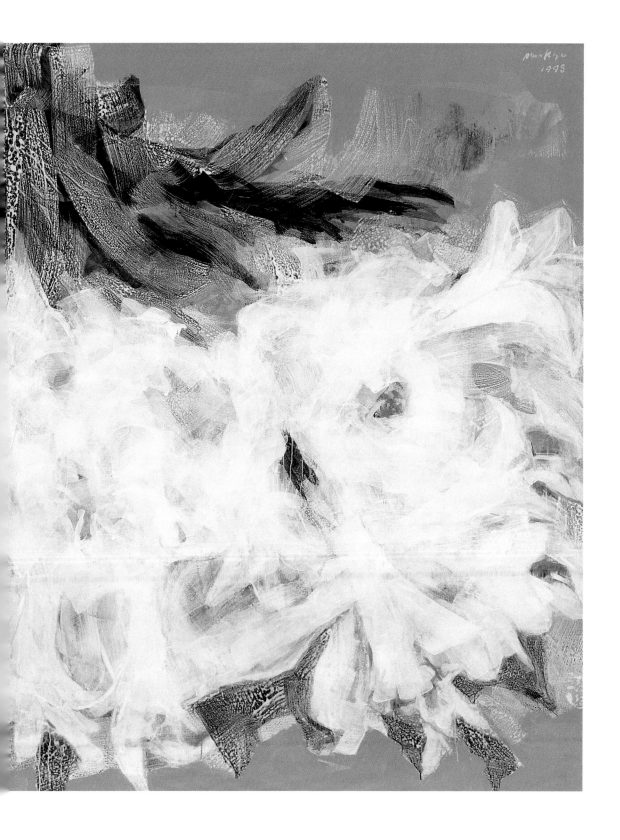

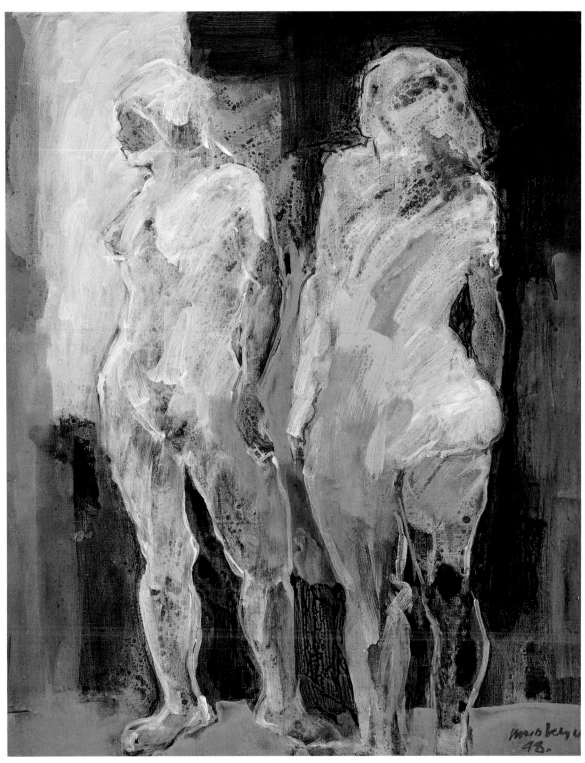

EVE 98−40a
1998, Acrylic on Canvas, 100.0×80.3cm

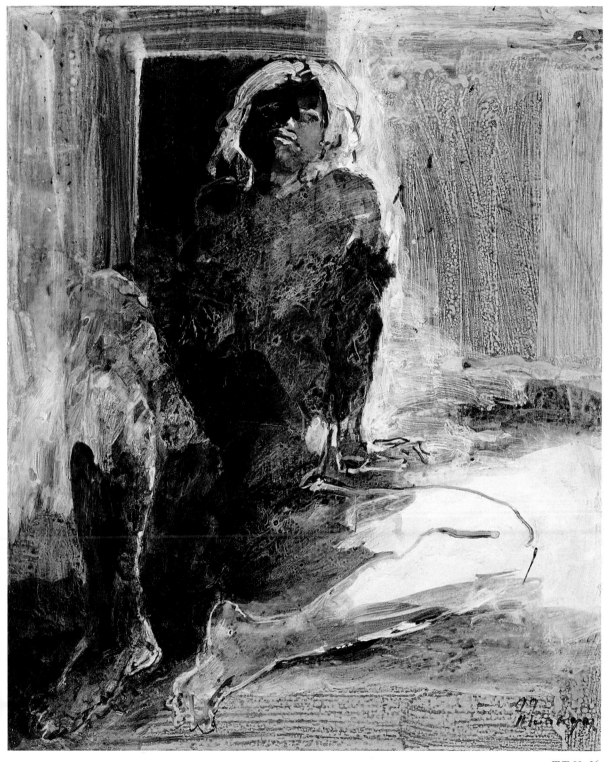

EVE 99−26
1999, Acrylic on Canvas, 80.3×65.1cm

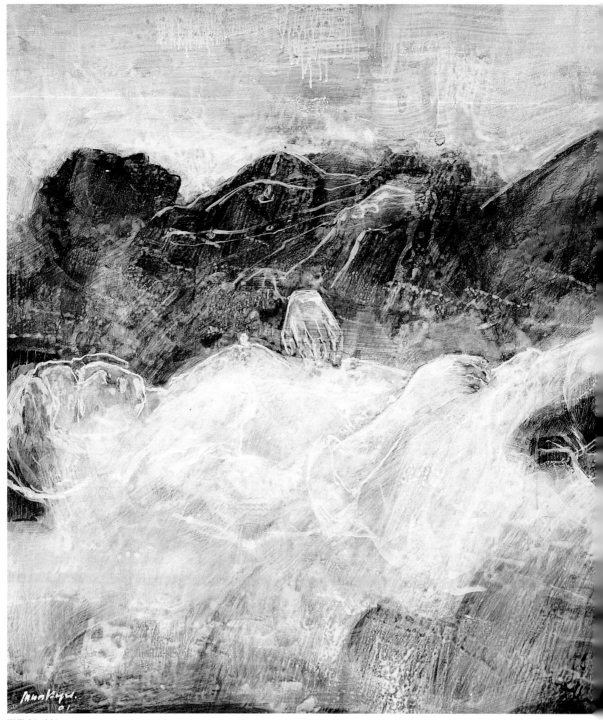

EVE 01-101
2001, Acrylic on Canvas, 130.3×162.2cm

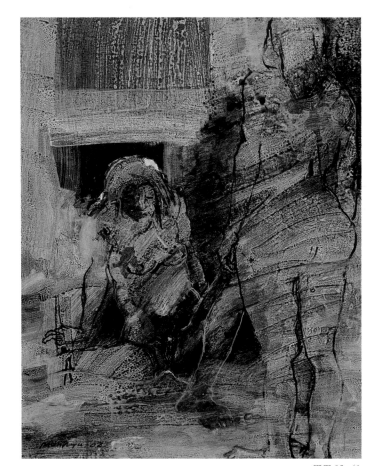

EVE 02-41
2002, Acrylic on Canvas, 90.9×72.7cm

순치된 자연과 정화된 풍경

김상철 / 월간 미술세계 주간 · 미술평론가

작가의 예술세계는 마치 유기적인 생명체와도 같아 부단한 변화를 통해 그 생명력을 유지하게 마련이다. 작가 정문규의 작업 역정 역시 부단한 변화의 과정을 거쳐 오늘에 이르고 있다. 60년대의 견고하고 침잠하는 깊이를 지닌 추상작업에서 칠하고 벗겨내는 반복적인 과정을 통해 인체의 내밀한 이미지를 구축해내던 70년대의 누드작업에 이르기까지 그의 작업은 지속적인 변화를 통해 그 영역을 넓히며 내용을 풍부히 해왔다. 이러한 변화

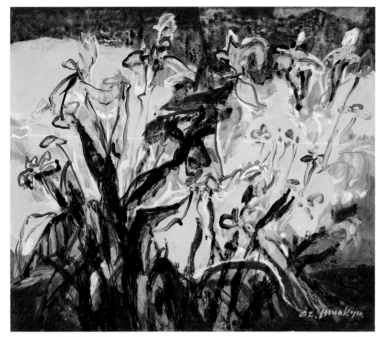

달맞이 꽃 Everning Prinrose
2002, Acrylic on Canvas, 45.5×53.0cm

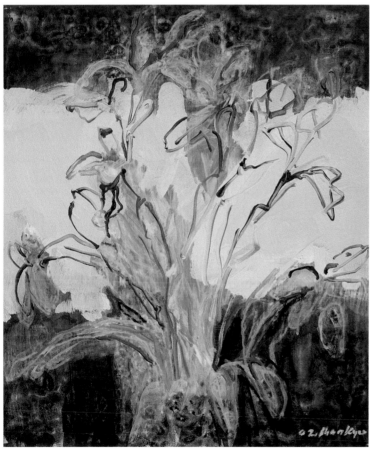

난 Orchid
2002, Acrylic on Canvas, 53.0×45.5cm

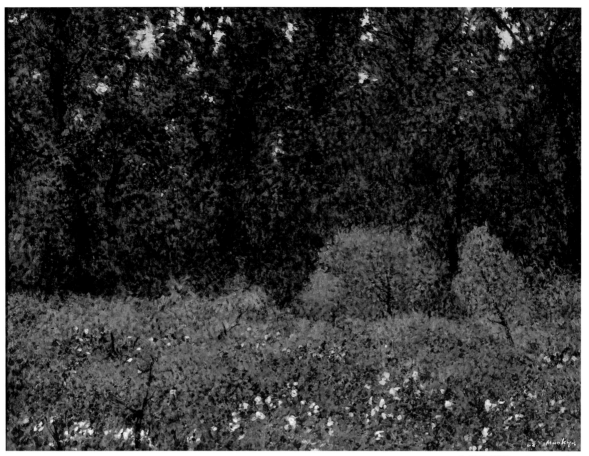

녹색의 정원 A Green gaden
2008, Acrylic on Canvas, 150.0×200.0cm

는 근작에 이르러 원색의 강렬한 생명력을 바탕으로 한 자연 풍광과 화훼류의 표현
으로 이어지고 있다.

　작가의 작업은 일정한 주기를 두고 양식적 변화를 보여주고 있으나 그의 작업에 일
관되게 관류하고 있는 가치는 인본주의(人本主義)를 바탕으로 한 따뜻한 감성이라 여
겨진다. 초기의 추상 표현주의적 경향의 작업이 황토색으로 대변되는 이 땅의 토속적
인 감성을 추상이라는 형식을 빌려 표출하고자 한 것이라면, 누드 연삭에 나타나는 정
서는 인간에 대한 본질적인 사유와 관심을 표명하는 것이라 할 수 있을 것이다. 작가
는 "나의 상대적인 성(性)인 여(女)를 통해서 거짓 없는 원초적인 참모습을 구하고 그것
이 우리에게 얼마만한 설득력을 지니는가의 시험을 계속하고 있다. 나는 그 속에서 무
한한 내 특유의 지유를 누리고 서기에서 창조적인 활력을 얻으려한다."라고 말한 바
있다. 작가는 누드라는 대상을 단순한 표현의 객체로 삼은 것이 아니라 그것을 통해
자신의 내면을 투사하고 조망하는 주체로서 받아들이고 있음을 의미하는 것이다.

　이러한 일련의 과정을 거쳐 작가의 작업은 원색의 명징한 색채가 두드러지는 자
연으로 귀착되고 있다. 일견 자연주의적 서정성이 두드러지는 새로운 경향의 작업들

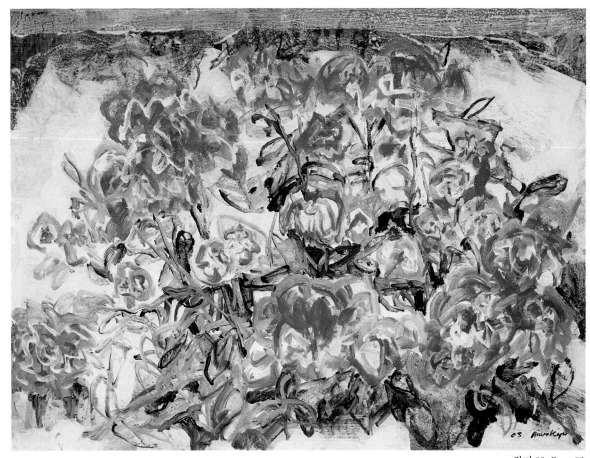

장미 03 Rose 03
2003, Acrylic on Canvas, 97.0×130.0cm

은 붉고 노란 원색들로 개괄되어져 욱욱한 자연의 생명력을 유감없이 드러내고 있다. 그것은 단순히 객관적인 자연의 재현이 아니라 일종의 기운의 표출이라 함이 보다 적확한 표현일 것이다. 형상 재현의 번잡스러움에서 벗어난 것이기에 작가의 화면은 원근이나 투시와 같은 이성적인 합리성을 고집하지 않는다. 오히려 평면화된 화면을 통하여 그 사유의 깊이를 더하고 있다. 그것은 구체적인 사물을 통하여 특정한 의미를 강조하거나 강요하는 것이 아니라 보는 이의 몫을 배려하고 또 다른 상상의 여지를 된보하는 깃이기도 하디. 객관혀 상항에 대하 설명이나 수식이 아니라 대상을 개괄하여 표현하는 작가의 시선은 다분히 관조적이다. 관조는 대상 자체에 함몰되지 않고 일정한 거리를 유지할 때 비로소 가능한 것이다. 그것은 육안에 의해 포착된 객관이라는 조건을 심안(心眼)을 통해 재구성하는 것이다. 이러한 과정을 거쳐 재구성된 자연은 일정한 이상화, 혹은 관념화되어 특정한 사유를 동반하게 된다. 즉 관조는 자연이라는 대상 자체에 집착하는 구상의 시각이 아니라 그 형상을 빌어 또 다른 의미와 가치를 표출하는 비의(比擬)의 시선이다.

작가에게 있어서 자연은 그저 아름다운 표현의 대상이라는 제한적 의미로 존재하는 것이 아니라 생명과 외경을 표출하는 매개로서의 의미가 더욱 강하다 할

장미 02-21 Rose 02-21
2002, Acrylic on Canvas,
92.5×60.5cm

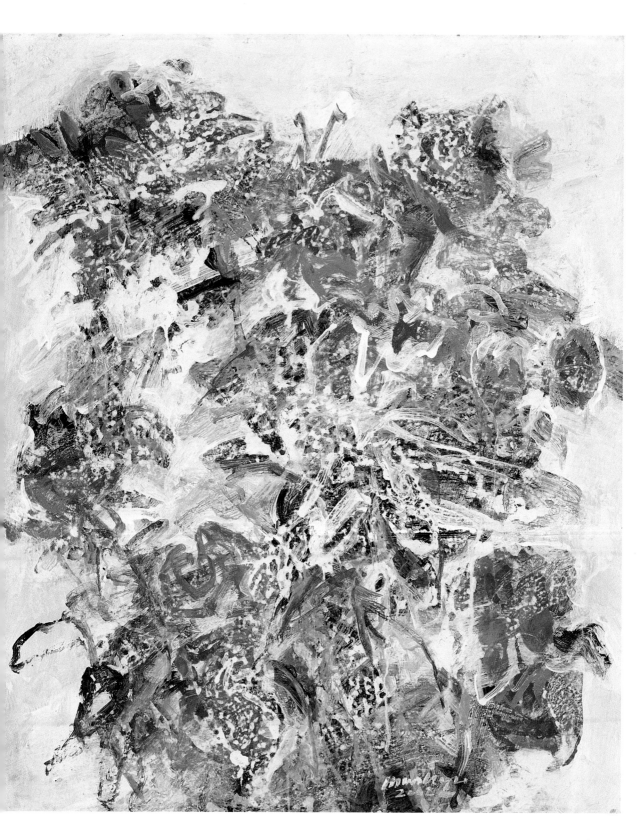

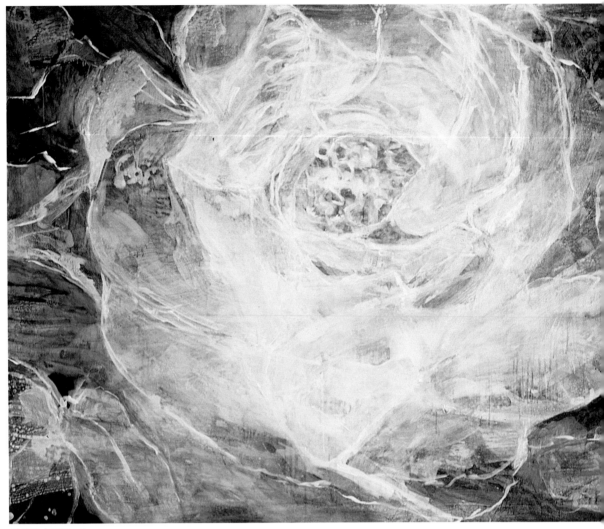

하얀장미 White Rose
2003, Acrylic on Canvas, 130.3×324.4cm

것이다. 비록 일정한 형상성을 지니고 있지만 작가의 작업을 그저 구상으로 치부할 수 없음은 바로 이러한 이유일 것이다.

　자연에 대한 인간의 관심은 원초적이고 내생적인 것이다. 작가가 토속적이고 향토성 짙은 추상작업에서 누드를 통한 인간의 본질적인 문제에 대한 탐구의 과정을 거쳐 자연에 대한 새로운 관심은 비록 형식에 있어서 확연한 차이를 드러내고 있으나, 그 이면을 일관되게 관류하고 있는 것은 바로 인본주의의 따뜻함이라 여겨진다. 특히 근작에 나타나는 자연에 대한 관조와 표현은 자연과 생명에 대한 경외의 찬사라 할 것이다. 작가에 의해 표현되는 자연은 소슬하고 처연한 가을이 아니라 신생의 기운이 넘치는 봄이나 강렬한 생명의 기운이 물씬 전해지는 여름의 풍광들이다. 그것은 단순히 계절에 대한 작가의 선호라기보다는 작가가 표출하고자 하는 근본적인 내용의 은밀한 암시라 읽혀진다. 어쩌면 작가

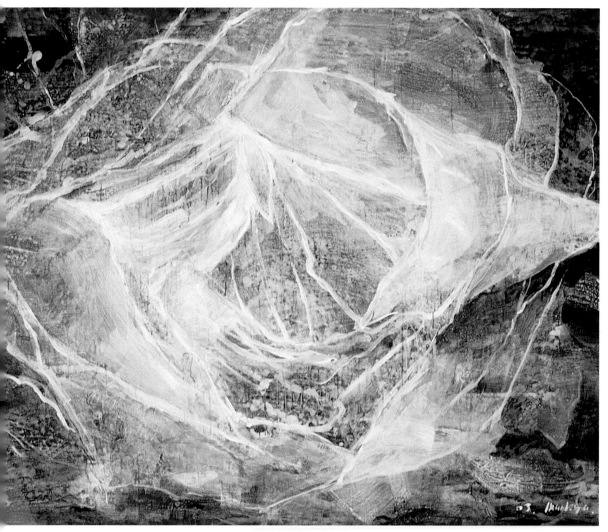

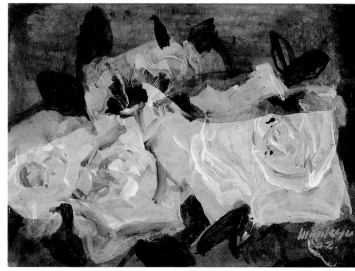

장미 02 Rose 02
2002, Acrylic on Canvas,
24.2×33.4cm

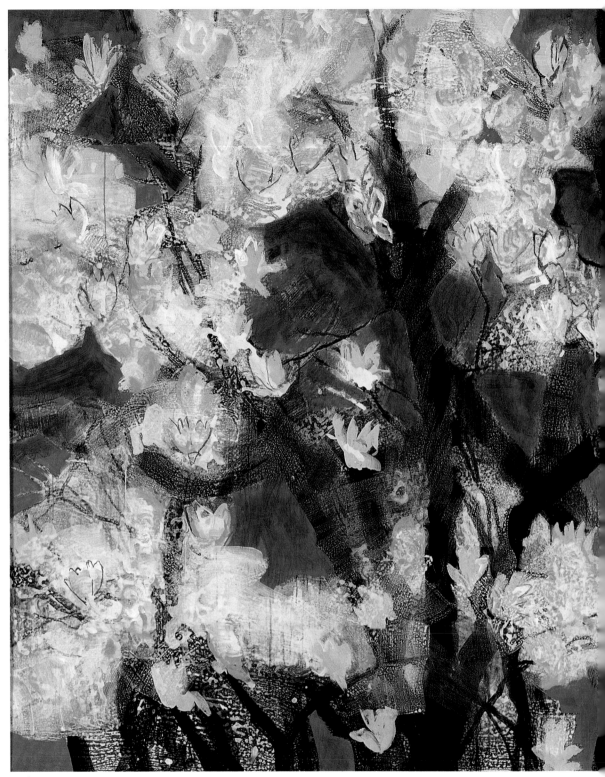

목련 Magnolia
2003, Acrylic on Canvas, 196.0×333.0cm

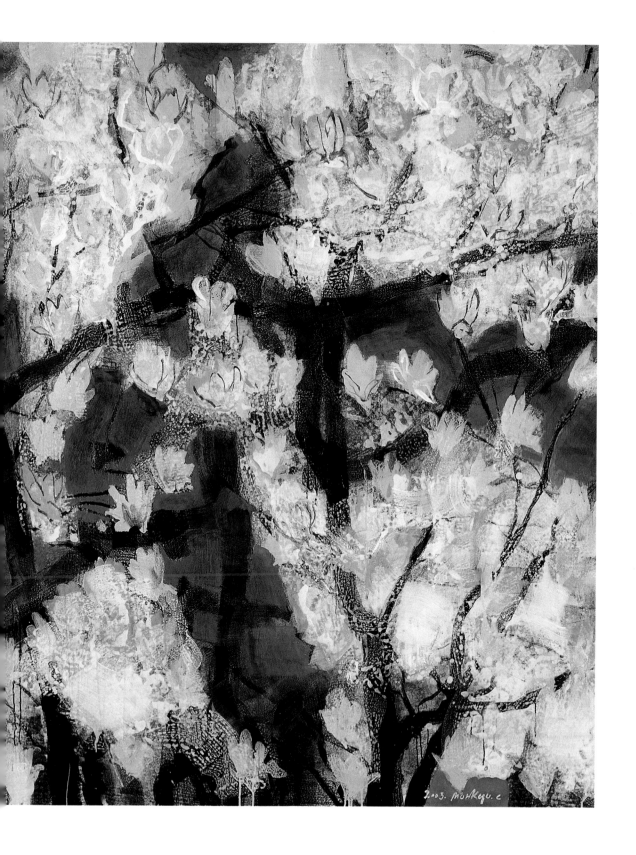

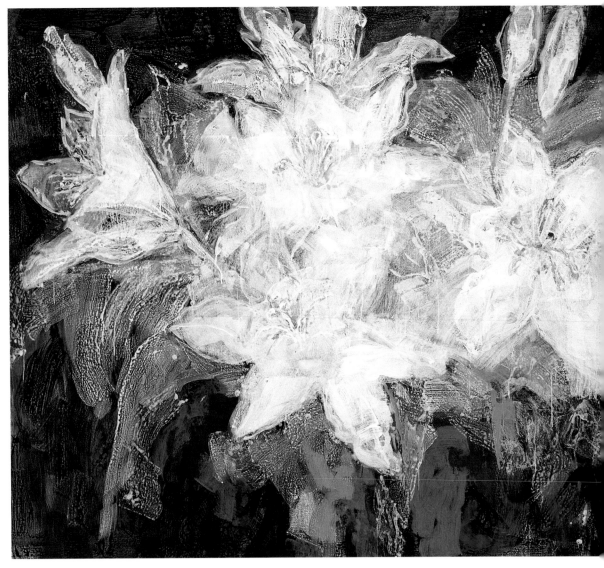

엉겅퀴 Thistle
2004, Acrylic on Canvas, 80.3×100.0cm

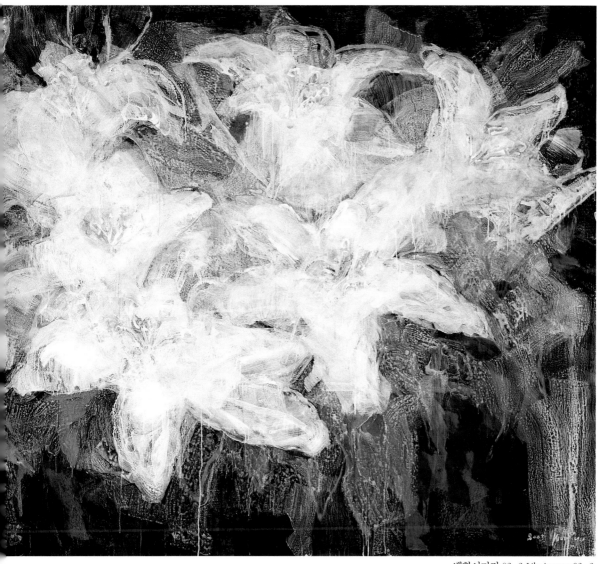

백합이미지 03-3 Lily image 03-3
2003, Acrylic on Canvas, 170.0×400.0cm

는 자연이나 계절의 표현에 앞서 생명과 자연의 경이로움과 조화로움의 사변을 형상과 색채를 빌어 토로하는 것인지도 모른다.

원색의 찬연한 색채와 거침없이 역동적이고 격정적인 운필은 작가가 포착한 자연의 근본적인 표정이다. 붉음은 무르익어 자주에 가깝고, 푸름은 깊고 깊어 아득하다. 그깃은 색채로 이루어지는 한편의 장엄한 交響곡과 같은 커다란 울림으로 나가온다. 수많은 우연과 무작위로 점철된 색채들은 서로 어우러지면서 조화를 이루는 가운데 형상은 절로 구축된다. 이는 온전히 작가의 작위, 혹은 조형의지로 이루어지는 물리적인 것이 아니라 대상과 표현에 대한 작가의 사유가 반영되어진 결과일 것이다. 즉 작위 하지만 강제하거나 집착하지 않고, 작위 하지 않지만 방만하여

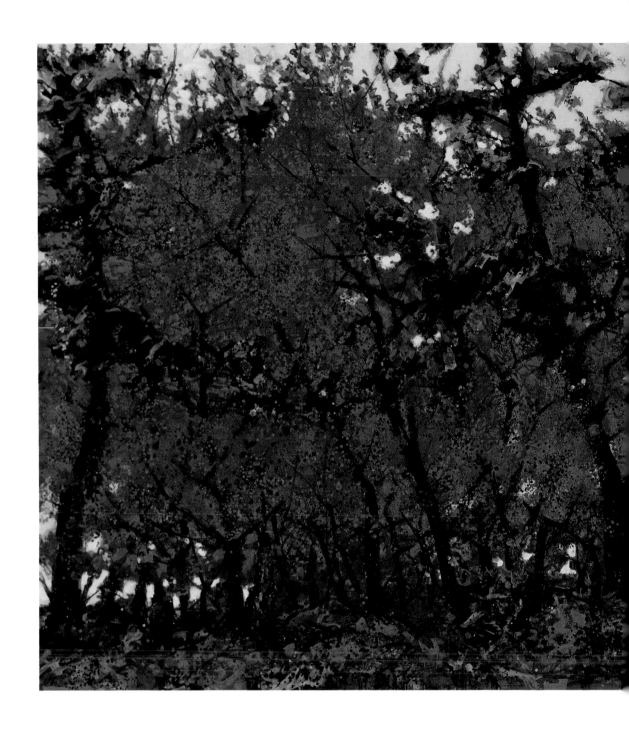

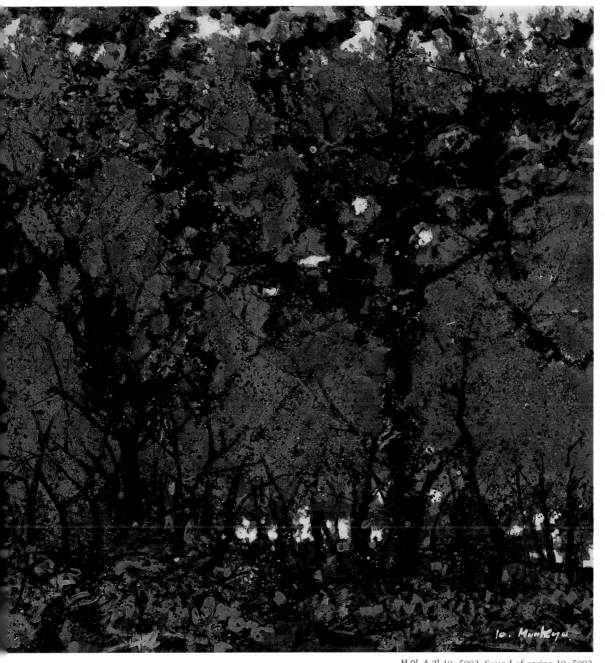

봄의 소리 10-5002 Sound of spring 10-5002
2010, Acrylic on Canvas, 200.0×400.0cm

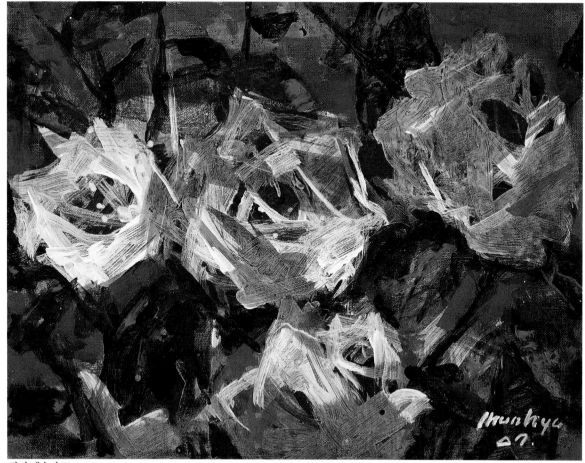

장미 네송이 Four rose
2007, Acrylic on Canvas, 31.8×40.9cm

허투로 흐름을 경계하는 운용의 묘는 작가의 화면을 더욱 풍부한 경지로 끌어 올리고 있다 할 것이다. 이는 재료와 표현에 대한 용인, 즉 우연적인 것과 필연적인 것, 인위적인 것과 자연적인 것을 구분하고 수렴해내는 안목과 지혜에서 비롯되는 독특한 경지라 할 것이다. 격정적인 필치와 색채로 자연을 표현하지만 정작 작가가 드러내고자 하는 것은 그 형상 너머에 자리하고 있는 생명에 대한 경외와 감사의 찬사일 것이다.

순간적이고 우연적인 것들의 집적을 통해 차츰 깊이를 더해가는 작가의 화면은 그렇게 보는 이의 시선을 화면 속으로 끌어들이며 그윽한 사색에 들게 한다. 특정한 색채로 개괄되어 표현되고 있는 자연의 밝고 맑은 원색은 선명하고 자극적인 것이지만 작가는 이를 오히려 강렬하고 역동적인 생명력으로 환치시키고 있다. 더불어 작가의 자연은 경직된 형식을 고집하거나 특정한 기법을 강조함이 없어 분방하고 자유롭지만 결코 번잡스럽거나 문란하지 않다. 이는 절로 스스로의 질서를 찾아가는 자연의 이치와도 매우 흡사하여, 노년의 원숙한 경지는 모든 것을 음악적인 질서로 수렴해 내고 있다 할 것이다. 그것은 일종의 순치이며 정화이다.

진달래 동산
2002, Acrylic on Canvas,
80.0×100.0cm

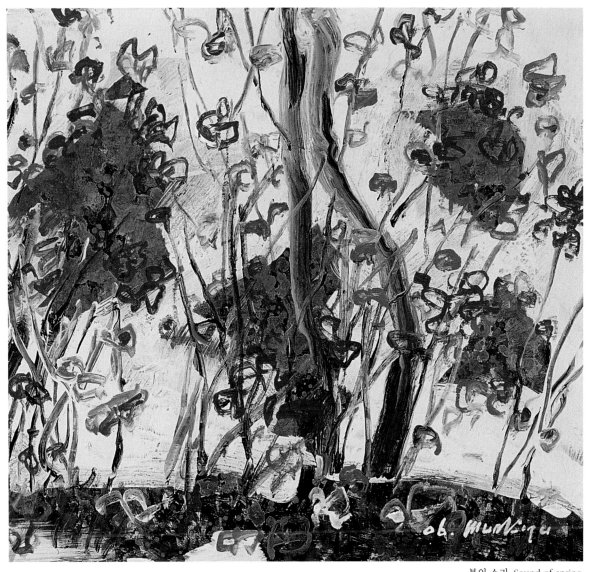

봄의 소리 Sound of spring
2006, Acrylic on Canvas, 45.5×106.0cm

작가의 작업은 근작에 들어 화면의 물리적인 크기도 대작으로 확대되고 있을 뿐 아니라 표현에 있어서도 더욱 역동적인 면이 두드러진다. 거침없는 필치와 넘쳐나는 기세는 청년의 그것을 방불케 한다. 대상에 대한 깊고 그윽한 관조의 시각과 오랜 삶을 통해 축적되어진 노경의 지혜는 그렇게 분출되며 자연과 생명에 대한 외경심을 표출하는 것이다.

엄청난 병마를 이겨내는 과정에서 삶에 대한 절박하고 진솔한 체험은 이러한 작업을 견인하는 가장 근본적인 동력일 것이다. 그러하기에 작가의 작업은 선연한 원색을 불꽃처럼 드러내지만 완전한 연소의 맑음으로 표현되는 것이라 여겨진다.

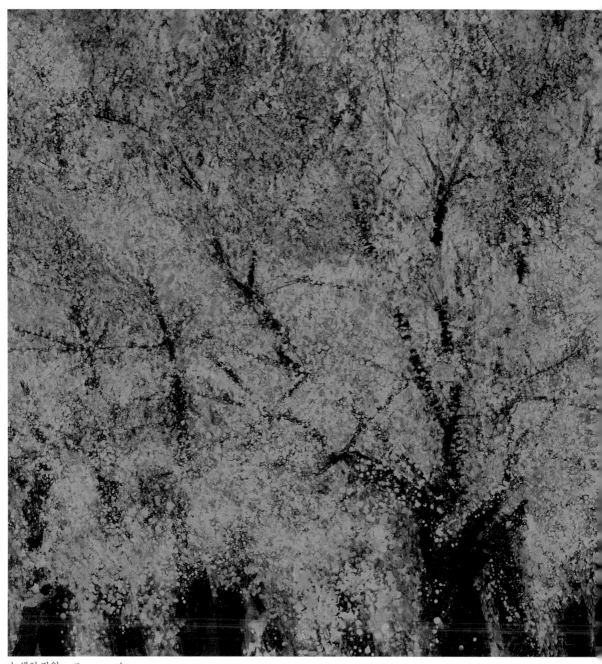

녹색의 장원 a Green gorden a
2006, Acrylic on Canvas, 200.0×400.0cm

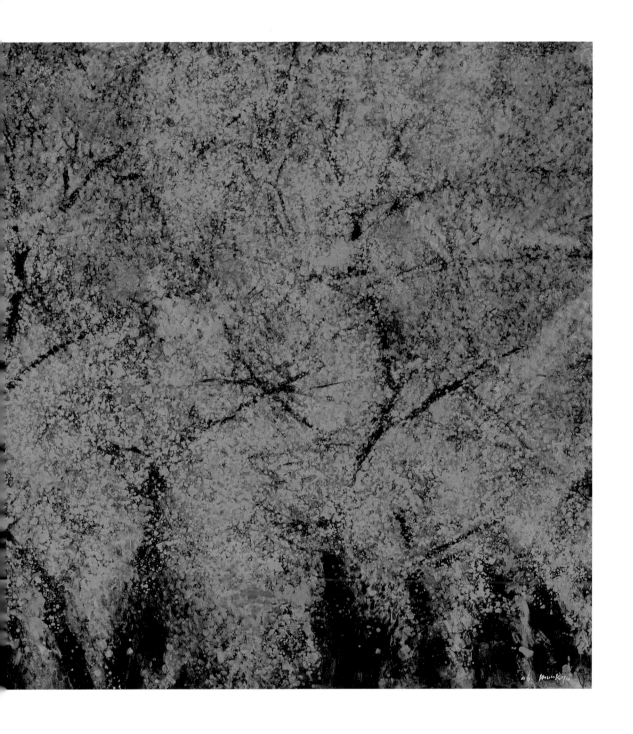

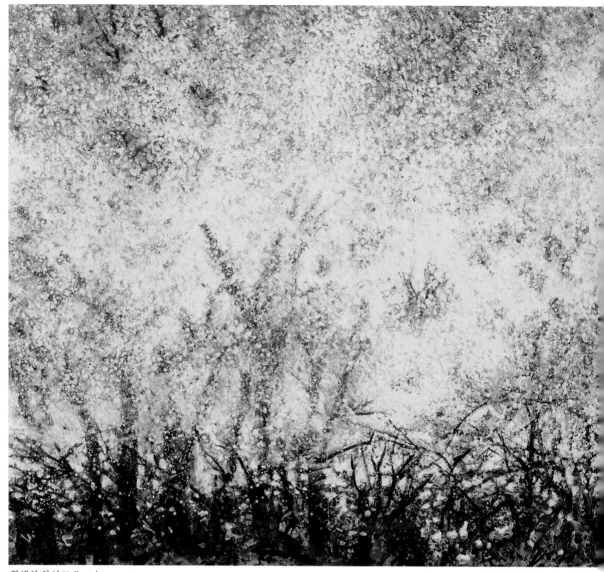

황색의 향연 Yellow banquet
2008, Acrylic on Canvas, 170.0×400.0cm

Pure Scenery and Nature Tamed

Kim Sangcheo / Managing Editor of Monthly Art Magazine
MISULSEGYE · Art Critique

The world of art for an artist is an organic living body maintainvitality. or artist Chung, Mun-kyu winding has reached the present through th process abstract work sound sediment depth starting in 1960s to nude works in 1970s.

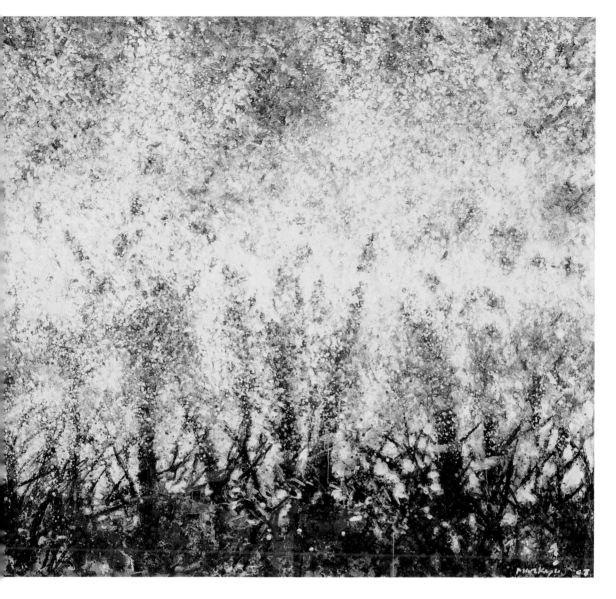

His nudes built up images of a deep abyss of the human body through the repeated process of painting and peeling over and over. Chung has strived to enrich the content of his work by continuously broadening the scope of his landscape. This type of change has led to the expression of natural scenery and flowers depicted with the powerful vitality of primary colors. While the works of this artist have displayed formative changes within a certain period, the innate value that consistently represents his work would be that of a warm sentiment on the basis of humanism. If it can be said that the works of his early days tended to fall under the category of abstract expressionism parlayed in the form of a folk sentiment coloring the yellow soil of the land, then the emotion displayed in his series of nude paintings would be that of the expression of the intrinsic causes and interest in humanity. The artist

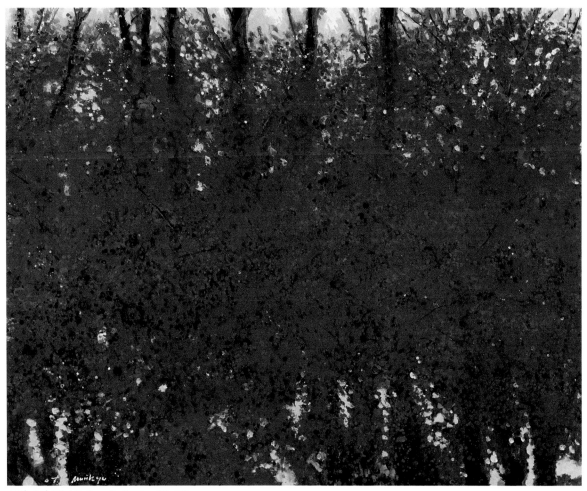

봄의 소리 07−101 Sound of spring 07−101
2007, Acrylic on Canvas, 130.3×162.2cm

개화의 계절 The flowering time
2007, Acrylic on Canvas, 45.5×106.0cm

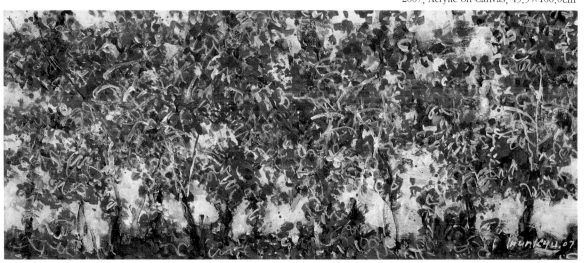

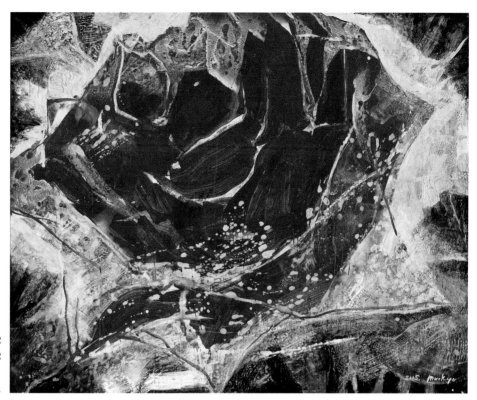

장미 05−102
Rose 05−102
2008, Acrylic on Canvas,
130.3×162.2cm

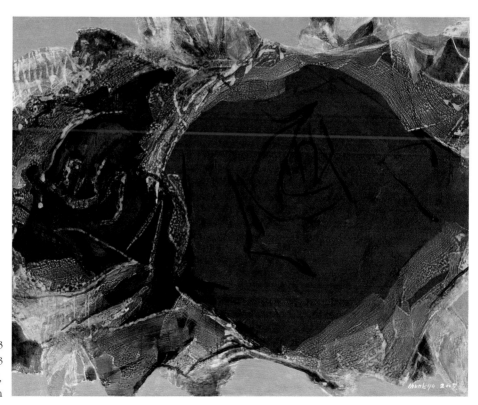

장미 05−103
Rose 05−103
2008, Acrylic on Canvas,
130.3×162.2cm

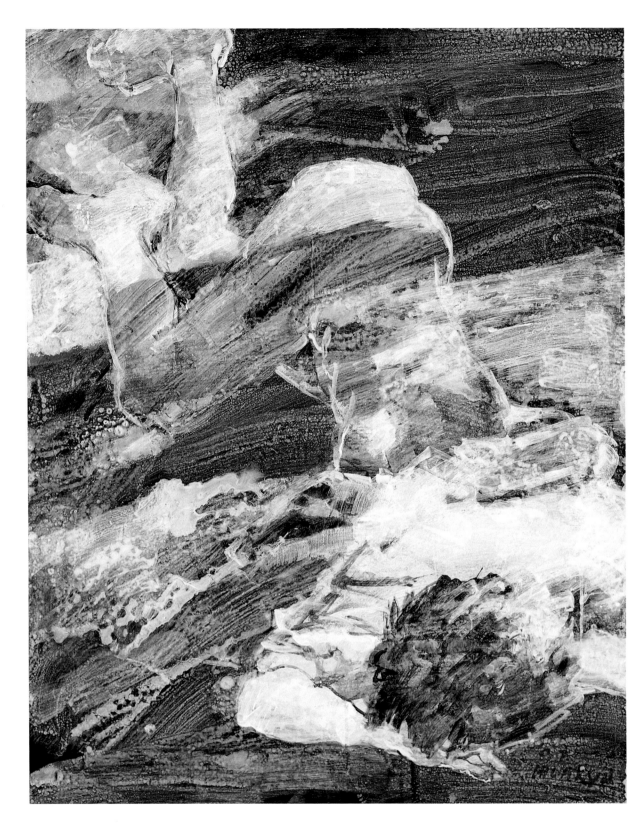

EVE 07–31
2007, Acrylic on Canvas,
90.9×72.7cm

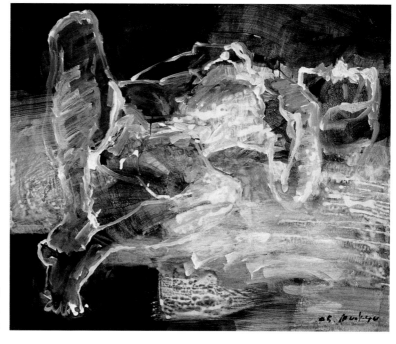

EVE 05–20
2005, Acrylic on Canvas,
60.6×72.7cm

once said, " I try to understand my core identity, my true essential self, through my gendering as a female person, and I am constantly testing the extent to which gender holds power over us. As I do this, I find that I enjoy a unique and unlimited freedom and gain creative energy from it." The artist did not just take the subject of nudity as the object of simple expression but he accepted it as a subject to penetrate through the inner part of himself and have the illustration thereof.

Through a series of processes, Chung's works have returned to nature with the conspicuousness of clear primary colors. These works with obvious new trends using naturalistic sensitivity are outlined with red and yellow colors to display the refreshing vitality of nature at its fullest. It would be more accurate to describe his work as an expression of a kind of energy, rather than a simply objective reproduction of nature. In departing from the complexities of reproducing form, the artist's images do not insist on the logical rationality of distance or perspective. Instead, through the leveled surface of the work, he adds a private depth. This depth is not an emphasis or imposition of a particular meaning conveyed through a concrete object but rather a show of consideration for what the viewer brings to the piece and the assurance of space for alternate imaginations. His work is not a mere description or modification of something objective, but rather the outline and contemplative expression of the subjective. Such contemplation is possible only after a certain distance is maintained away from submersion into the subject itself, which means to objectively restructure the condition by capturing essence through the bare eyes of insight. Nature restructured through this process would become idealized or conceptualized to accompany a specific cause. In other words, contemplation is not the

녹색의 장원 b Green gorden b
2007, Acrylic on Canvas, 200.0×400.0cm

viewpoint of conception that aims to persist on the subject of nature itself, but rather to borrow the image in order to formulate the other implication and value as the view of ratio. For the artist, nature does not exist as a restrictive meaning but to have an even stronger implication as the medium in which to express life and respect. Although it has a certain process and culmination, the works of the artist cannot simply be considered as a concept for the foregoing reasons.

Interest in human nature is basic and innate. Although the artist's new interest in nature, which he explores through the intrinsic issues of humans related from the nude to everyday folk to local abstract works, might reveal clear differences in forms and shapes, what can consistently be found in all of his work is the warmth of humanism. In particular, contemplation and expression of nature as it has appeared in his recent works can be considered as a kind of praise in awe of nature and life itself. Nature expressed by the artist is not a desolate, solitary autumn but the scenery of a spring overflowing with new energy or a summer bursting with powerful vitality. This is viewed as secret implication of fundamental components that the artist intends to express rather than as a preference for particular seasons. Perhaps the artist intends to release the amazing aspects of life and nature, and the harmonious variations of shape and color, rather than merely depicting a particular season or scene.

Splendid primary colors and thrusting, dynamic and passionate brushwork are the fundamental expressions of nature that the artist has been able to capture. Red resembles violet with a full ripeness and blue so deep it incites dizziness. These colors reach out to the viewer like a

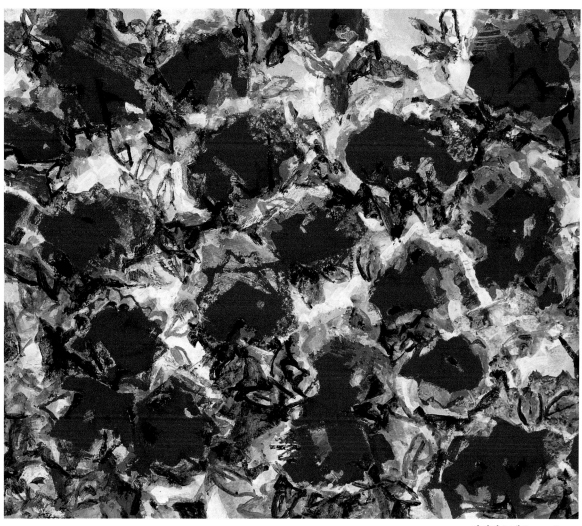

장미의 노래 Song of rose
2009, Acrylic on Canvas, 80.3×200.0cm

magnificent symphony rendered in the tones of vivid color. Coincidences and randomly placed colors achieve harmony with the natural structure of identifiable shapes. This is not entirely a physical fulfillment of the author's pretense or artistic volition but rather a reflection of the author's thoughts about his subject and representation. In other words, the artist's strategy of a pretense that is neither forced nor fixated, and a lack of pretense that is neither loose nor sloppy, elevates his work to a much richer level. This level can be described as a tolerance for material and expression, that is, a distinctive level that begins from wisdom and an eye for distinguishing between the accidental and the inevitable, the artificial and the natural. Nature is expressed with passionate brushwork and color, but what the artist really wishes to display is the respect given to life and praise of pure appreciation beyond the images themselves.

Viewers have been attracted to the artist's canvas that bring depth through the integration of the momentary and the coincidental, inciting a deeper contemplation. The bright and clear primary colors of nature that would normally be outlined and expressed in specific colors are clear and suggestive but the artist turns them into something powerful and dynamic in of themselves. In addition, the nature of the artist's work does not insist on rigid forms, set techniques or lewd, chaotic depictions even though he is able to express himself freely. This is very similar to the principle of nature that a mature person of his time would bring out to

봄의 소리 10 Sound of spring 10
2010, Acrylic on Canvas,
196.0×350.0cm

reveal the musical order in all things. It is a type of taming and purification. Chung's works have expanded into physically larger pieces with more dynamic expressive aspects. The unbound writer's touch and powerful posture are comparable to those of his youth. Achieving wisdom found only after years of deep contemplation accumulated over a long life, his works express true respect of nature and life itself. While struggling to prevail over a major illness, his desperate and profound experience on life may be the most fundamental force driving his works. As is such, the works of Chung, Mun-kyu can be clearly expressed with complete combustion as displayed in the flame of primary colors.

정문규 연보

1934 경남 출생
1947-53 진주 사범학교졸업. 미술부 활동
영남예술제 (현 개천예술제) 1,2,3회 가작
상, 문교부장관상, 개천예술상 수상
1954-58 홍익대학 미술학부 회화과 졸업
1963-66 홍익대학 출강
1966-99 인천교육대학교 교수
1968-70 일본문부성 장학생으로 동경예
술대학 대학원 유학
1971-78 국민대학교 출강
1994 제3회 최영림 미술상 수상
1999 인천교육대학교 교수 정년퇴임

연혁 및 활동실적
1955 -진주화랑다방 (청동) 제1회 개인전
화가 박생광다방
1959 -제2회 개인전 (동화화랑), 제작동인
전 (국립도서관화랑)
1960 -조선일보 현대작가 초대전 (국립현
대미술관)
1962 -제3회 개인전 (국립도서관화랑)
1963 -신상회 창립회원전 (국립현대미술관)
1964 -동경올림픽 한국현대미전 (국립현대

미술관)
1966 -제4회 개인전 (신세계화랑)
1971 -제5회 개인전 (도라장화랑)
1975 -제6회 개인전 (미술회관)
-공간대상전 (덕수궁현대미술관)
1977 -국립현대미술관기획 서영화 대전
(국립현대미술관)
-한국일보 대상전 초대전
-현대화랑기획 신춘초대전
-제7회 개인전 (견지화랑)
-한국화랑 개관전
1978 -제1회 중앙미술대전초대(호암미술
관, 덕수궁현대미술관)
1979 -제8회 개인전 (관훈미술관)
-문예진흥원기획 한국미술 오늘의 방법전
(덕수궁현대미술관)
-제2회 중앙미술대전 초대전 (덕수궁현대
미술관)
-화랑협회기획 제1회 미술대전
1980 -제9회 개인전 (파리Vercamel화랑)
1981 -재불화가전 재불한국문화원기획
-제10회 개인전 (동산방화랑 초대)
1982 -현대미술초대전 (국립현대미술관)
-이태리 밀라노 한국현대미술전

1983 -현대미술초대전 (국립현대미술관)
1984 -현대미술초대전 (국립현대미술관전)
1985 -현대미술초대전 (국립현대미술관)
-프랑스 파리 한국현대미술전 그랑팔레
-국립현대미술관기획 광복 40주년 기념전
(국립현대미술관)
1986 -86현대미술초대전 (국립현대미술관)
-한·불 수교 100주년 기념 서울 파리전
(서울갤러리 조형미술)
-아시안게임 조직위원회 기획(아시안게임
특별전시관)
-국립현대미술관 이전개관기념 (과천국립
현대미술관)
1987 -현대미술초대전 (국립현대미술관)
-서울미술대전 (국립현대미술관)
-아시아 국제미술전 (중화민국 대만)
-제11회 개인전 (서울갤러리)
1988 -한국현대미술전-국립현대미술관
초대(국립현대미술관)
-서울미술대전-서울시 초대(서울시립미
술관)
-제3회 아세아 국제미술전람회(일본 후쿠
오카 시립미술관)
1989 -현대미술초대전 (국립현대미술관)

1953 진주사범학교 졸업식-故홍영표 선생님을 모시고

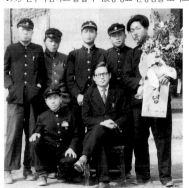

1958 홍익대학교 졸업식날

1959 제작동인전

1971 도라장 화랑 개인전 – 故박세림 선생과 함께

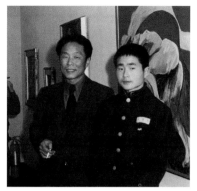

1975 문예진흥원 미술회관 개인전

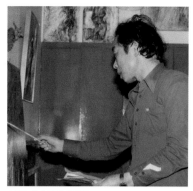

1980 파리에서 작업중

-제4회 아세아 국제미술전람회 (서울시립미술관)

1990 -현대미술초대전 (국립현대미술관)

-서울미술대전 (서울시립미술관)

-개관기념 · 한국미술 – 오늘의 상황전 (예술의 전당)

1991 -현대미술초대전 (국립현대미술관)

-서울미술대전 (서울시립미술관)

-현대미술과 에로티시즘전 (엠,아트갤러리 기획)

1992 -현대미술초대전 (국립현대미술관)

-서울미술대전 (서울시립미술관)

1994 -제3회 최영림 미술상수상 (최영림미술상 운영위원회)

1995 -한국현대미술 파리전 (convent des cordeliers)

1996 -한국누드 80년전 (예술의전당)

1998 -MANIF 98전 (예술의전당)

1999 -제1회 단원미술제 '99 안산 운영위원장

-Manif Seoul '99 Adam&Eve 전 초대

-서울미술대전 초대 (서울시립미술관)

-제18회 대한민국 미술대전 심사위원장

-한국미술 '99-인간, 자연, 사물 전 초대 (국립현대미술관)

2000 -움직이는 미술관 (국립현대미술관)

-제2회 단원미술제 '2000 안산 운영위원장)

-한국현대미술의 시원전 초대 (국립현대미술관)

-파리 '살롱2000 그링에쥔느' 전 초대

-SJ Art Gallery 개관 초대전

2001 -프랑스 '마르세이유 국제박람회' 작품초대참가

-찾아가는 미술관 (국립현대미술관 지방순회전)

-세종문화회관 미술관 개관전 초대

-제53회 대한민국 문화예술상 미술부분 수상

2002 -프랑스 살롱 그랑에쥔느 세계순회 서울전(세종문화회관)

-한 · 일 현대미술관 초대

-제3회 이인성 미술상 심사위원장

2003 -제14회 개인전 (우덕갤러리 초대)

-한 · 일 현대미술 교류전

-서울미술대전 초대 (서울시립미술관)

-파리 살롱 도돈느 초대

2004 -파리 콩파래숑전 초대

-경남 도립 미술관 개관 원로 작가전 초대

-한 · 일 현대미술 교류전 (후쿠오카미술관)

-고난 속에 피어난 추상전(1958~1965 때의 추상작품전시-미아미술관 개관전)

2005 -한 · 일 현대미술교류전 (세종문화회관 미술관)

-한 · 중 현대미술교류전(중국심천, 세종문화회관 미술관)

-제1회 한국구상대전 초대 (MANIF, 예술의전당)

-서울미술대전 초대 (시울시립미술관)

2006 -부산시립미술관초대(1950~60년대 추상작품 개인전)

-제2회 한국구상대제전 초대(MANIF, 예술의전당) 조직위원장역임

-월드아티스트 페스티벌 초대

2007 -Oriental Visual 한중수교 20주년 기념

-한중교류전 초대 (중국정부주최)

-제3회 구상대제전 초대 (MANIF, 예술의전당)

-제4회 오픈옥션 아트스타 100축전 아트페어 초대 (코엑스 전시관)

-인천 국제여성비엔날레 자문위원

2008 -제4회 구상대제전 초대 (MANIF, 예술의전당)

-제32회 상형전 (세종문화회관 미술관)

-골든아이 아트페어 제2회 오픈옥션 초대 (코엑스 전시관)

-서울미술대전초대 (서울시립미술관)

-남송국제아트페어초대 (성남 문화예술회관)

2009 -제5회 구상대제전 초대 (MANIF, 예술의전당)

-안산국제 아트페어 초대

-미술과비평

-정문규 미술관 개관

2010 -남송국제 아트쇼 초대 (성남 문화예술회관)

-제4회 경기도립미술관 '경기도의 힘' 전 초대

-회고전(서울에술의전당)

현재

(사)한국미술협회 고문

상형전 고문

1991 헝가리 부다페스트 여행중 – 문신개인전 1996 북경에서 1999 경인교육대학교 정년퇴임식 (동덕 아트센터)

Chung Mun Kyu Biography

1934 Born at Kyungnam

1947-1953 Graduated from Educational school in Jinju. Participated in art club in school

–Korean War broke out

–Won prize at 1st, 2nd, 3rd Yongnam art festival which later changed its name to Kaechun Art Festival

–In the first year his work was the next best to the prize winner and he received a prize from Ministry of Educational in the second tear In third year of the festival, he won the grand prize of Kaechun Art Festival

1954-58 Entered the Art Department of Hong Ik University in and graduated in 1958

1963-66 Started lecturing at Hong Ik University

1966-99 Professor at Incheon Educational University

1968-70 Studies at Yokyo Graduate School of Art on scholarship provided by Education Department of Japan

1978-81 Resided at Paris, France

1999 Retirement under the age limit from Incheon Educational University

History of Career and Accomplishment

1955 –1st private exhibition Cafe gallery in Jinju (Chungdong)

1959 –2nd private exhibition (Dongwha Gallery)

1960 –Preview of modern artist by Chosun Ilbo News

1962 –3rd private exhibition (Gallery at National Library)

1963 –Opening exhibition of Shinsang Society (National Museum of Contemporary Art, Korea)

1964 –2nd exhibition of Shinsang Society (National Museum of Contemporary Art, Korea)

–Tokyo Olympic exhibition for the modern art Korea (National Museum of Contemporary Art, Korea)

1966 –4th private exhibition (Shinsegae Gallery)

1971 –5th private exhibition (Dorajang

Gallery)

1975 –6th private exhibition (Art Hall)

Nude exhibition of modern artist Korea (Planned Areum Gallery)

–Grand exhibition of space (Modern Art Museum of Deoksugung)

1976 –Oil Painting exhibition of 50 artists (Planned by Yangi Gallery)

–100 western Painters Participated Opening exhibition of Munhwa Gallery

1977 –Grand exhibition of western painting (National Museum of Contemporary Art, Korea)

1978 –First Choongang grand art exhibition (Hoam museum, Modern Art Museum of Deoksugung)

1979 –8th private exhibition (Kwanhun Art Museum)

–Exhibition of current methodology in

–Korean art (Planned by Korea Culture and Art foundation)

–2nd Choongang grand art exhibition (Modern Art Museum of Deoksugung) First grand art exhibition Planned by Gallery Association

1980 −9th private exhibition (Vercamel Gallery in Paris)

1981 −Exhibition of Korean Artist in France Planned by Korean Culture Center in France

−2nd Grand Exhibition of Korean Art Sponsored by Myungsung Group (Art Hall)

−10th private exhibition (Preview of Dongsanbang Gallery)

1982 −Exhibition of Korean Modern Art Milano, Italy

1983-92 −Preview of modern art (National Museum of Contemporary Art, Korea)

1985 −Exhibition of Korean modern art in Paris (Grand Palais)

−Memorial exhibition of 40th Independence (Planned by and held at National Museum of Contemporary Art, Korea)

1985-92 −Seoul grand art exhibition Planned by Seoul City (National Museum of Contemporary Art, Korea)

1986 −Exhibition of "Seoul-Paris" 100th anniversary of amity between Korea and France (Seoul Gallery, Art Center for Sculptures)

− '86 Exhibition of Korean Art Current Situation (Special Exhibition Hall for the Asian Games)

−Opening Exhibition of National Museum of Contemporary Art, Korea)

−Preview of televised artists by KBS (Art Hall)

1987 −Preview of modern art (National Museum of Contemporary Art, Korea)

−Asian art exhibition (Taiwan)

−11th private exhibition (Seoul Gallery)

1988 −Exhibition of modern art in Korea (National Museum of Contemporary Art, Korea)

− '88 Seoul grand art exhibition (Seoul Museum of Art)

1989 −10th anniversary exhibition of Kwanhun Art Museum)

1990 −Preview of modern art (National Museum of Contemporary Art, Korea)

−Korean Art-current situation (Seoul Arts Center)

1992 −Preview of concrete artists in Korea (Invited by Dongback Art Museum in Pusan)

−Preview of modern art (National Museum of Contemporary Art, Korea)

1993 −Current exhibition of concrete art (Preview of Jungsong Gallery)

1994 −Won prize from the 3rd Choi,Young-lim Art Award (Operation board of Choi,Young-lim Art Award)

−International modern art festival for the 600th anniversary of Seoul

1995 −Exhibition of Changan society (Chosun Gallery)

−Exhibition of Korean intellects (Gongpyeong gallery, Kyosu Newspaper)

−Exhibition of Paris-Korean modern art (Convent des cordeliers)

1996 −Exhibition of Nude in Korea 80 years of history (Seoul Arts Center)

1997 −Exhibition of Changan society (Chong-Ro Gallery)

−Exhibition of professors at Incheon Educational University

1998 −MANIF Exhibition (Seoul Arts Center)

1999 −Preview exhibition (60 pieces from his old and recent work) (Dongduk Art Gallery)

−Invited to Seoul Art Exhibition (Seoul Museum of Art)

−Invited to Korea Art 'Human, Nature, Thing' Exhibition (National Museum of Contemporary Art, Korea)

2000 −Moving Museum of Art (National Museum of Contemporary Art, Korea)

−Head of the Ansan steering committee of the 2nd Danwon Arts Festival

−Invited 'Salon Grandes et jeunes −d' aujourd' hui 2000" in Paris

−Invitational for the Opening of SJ Art Gallery

−The 25th Hieroglypics Exhibition

2001 −Participated in Invitational for 'The

정문규 미술관 (2009년 개관·경기도 안산시 단원구 선감동 680−9 TEL 032-881-2753)

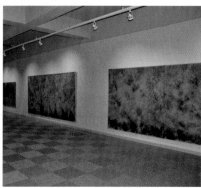

2001 문화예술상 수상기념

2002 한·일 교류전

2005 구상대제전 전시중에

Marseilles International Fair' in France
−Visiting Museum of Art (District Circulating Exhibition of National Museum of Contemporary Art, Korea)
−Invitational for the 3rd Danwon Arts Festival
−Invited to the Opening Exhibition for the Sejong Center
−The 26th Hieroglypics Exhibition
−Won a prize of Art Sector of the 53th Korea Culture & Art Awards
2002 −Salon Grandes et jeunes d' aujourd' hui World Circulating Seoul Exhibition (the Sejong Center)
−Invited to the 2002 Korea-Japan Museum of Modern Art
−The 27th Hieroglyphics Exhibition
−Foreman of a Jury of the 3rd Lee, In-seong Art Awards
2003 −14th private Exhibition (Invited by the Woodeok Gallery)
−Korea-Japan Exchange Exhibition of Modern Art
−Steering Committee member of Lee, In seong Art Awards
−Invited to Seoul Art Contest (Seoul Museum of Art)
−The 28th Hieroglyphics Exhibition
−Invited by Salon Grandes et jeunes
−d' aujourd' hui in Paris
2004 −Invited to Exhibition of Comparaision Paris
−Steering Committe Member of Lee, In-seong Art Awards

−Invited to Senior Artist Exhibition for the Opening of the Gyeong Art Museum
−Korea-Japan Exchange Exhibition of Modern Art (Fukuoka Art Museum)
−The 29th Hieroglyphics Exhibition (the Sejong Center)
−Abstract Exhibition blooming in Hardships (Display of Abstract artworks in the period of 1958 ~1965)and Opening Exhibition of Mia Art Museum
2005 −Korea · Japan Exchange Exhibition of Modern Art (the Sejong Center)
−Korea · China Exchange Exhibition of Modern Art (Simcheon, China, & the Sejong Center)
−Invited to the 1st Korean Representational Art Exhibition (MANIF, Seoul Arts Center)
−Invited to the Seoul Art Exhibition (Seoul Museum of Art)
2006 −Invited by the Busan Museum of Art (Private Exhibition of abstract works in the '50s and '60s)
−Invited and took the post of head of the organizing committee of the 2nd Korea Representational Art Exhibition (MANIF, Seoul Arts Center)
−Invited to World Artist Festival
−The 30th Hieroglyphics Exhibition (the Sejong Center)
2007 −Invited to Korea-China Exchange Exhibition, 'Oriental Visual', in honor of the 20th anniversary of amity between Korea and China (hosted by

the Chinese Government)
−Invited to the 3rd Representational Art Exhibition (MANIF, Seoul Arts Center)
−The 31th Hieroglyphics Exhibition (the Sejong Center)
−Invited to the 4th Open Auction Art Star 100 Festival Art Fair (Exhibit Hall, Coex)
−Consultant at Incheon International Women's Biennale
2008 −Invited to the 4th Representational Art Festival (MANIF, Seoul Arts Center)
−Invited to the 2nd Open Auction of Golden Eye Art Fair (Exhibit Hall, COEX)
−Invited to the Seoul Art Exhibition (Seoul Museum of Art)
−Invited to Namsong International Art Fair (Seongnam Arts Center)
2009 −Invited to the 5th Representational Art Festival (MANIF, Seoul Arts Center)
−Invited to the Ansan International Art Fair
−Opening of the Chung, Mun-kyu Museum
2010 −Invited to the 2010 Namsong International Art Show (Seongnam Arts Center)
−Invited to the 4th "Gyeonggido Strength" Exhibition at the Gyeonggi Museum of Modern Art
−Invited to 'Cornerstone Exhibition for
−Incheon Art" (Incheon Culture & Art Center)